Siegmund Forst

A LIFETIME IN
ARTS & LETTERS

Siegmund Forst

A LIFETIME IN ARTS & LETTERS

Yeshiva University Museum

This catalogue accompanies the
Yeshiva University Museum exhibition
Siegmund Forst: A Lifetime in Arts & Letters,
September 21, 1997 – July 31, 1998.

Cover illustration: *Mitzvot*, watercolor on paper, 1993.
Collection of Arthur Marx

Cover design: Lili Wronker

ISBN 0-945447-09-4

This Hebrew calligraphic rendering of the phrase *"The generous of heart shall be praised"* was created by Lynn Broide in tribute to the anonymous donor who sponsored the exhibition and catalogue.

Acknowledgements

I am deeply indebted to a large number of people who not only provided information and material for the exhibition and catalogue, but also offered encouragement and friendship: Sylvia A. Herskowitz, Director of Yeshiva University Museum initiated the project; her wise and helpful counsel in all matters has been steadfast throughout this process. Ita Aber, exhibition consultant, provided the initial survey of Forst's artworks. Reba Wulkan, Yeshiva University Museum Contemporary Exhibitions Coordinator deserves a special note of thanks. She labored long and hard and contributed a great deal to the exhibition's and catalogue's success. I could always also rely on the other members of the Museum staff for their expertise and guidance: Gabriel Goldstein, Randi Glickberg, Bonni-Dara Michaels, Eleanor Chiger and Joelle Bollag. Emily Scherer Steinberg, Senior designer of the University's graphics department, designed this catalogue; Norman Goldberg and Marc Becker of the University's photographic services provided the photography. Rabbi Shmuel Segal expended great effort in obtaining certain objects for the exhibition, and Rabbi Joseph Kalatsky was always available to answer questions.

Without these talented people there could be neither exhibition nor catalogue. I also express my appreciation to the anonymous donor whose magnanimity has made all this possible. Special gratitude is extended to the lenders whose generosity in sharing has enriched our knowledge of Jewish arts and letters: (in alphabetical order) Lynn Broide, Manya Fink, Rabbi Benjamin Forst, Siegmund Forst, Mr. and Mrs. Israel Friedman, Paul Gropman, Rena Kronenthal, Lucy Lang, William Loewy, Arthur Marx, The Moldovan Family Collection, Irene Neurath, and Lili Wronker.

Lynn Broide and Lili Wronker, both calligraphers and longtime admirers of Siegmund Forst, deserve to be singled out for their enthusiastic efforts to make this exhibition successful—they lent works to the exhibition and expended great efforts in locating and obtaining Forst pieces in Israel and the United States. Lynn graciously created the superb calligraphic dedication page in honor of the anonymous donor, and in the same manner, Lili designed and created the beautiful cover of the catalogue.

On a personal note, I have been greatly enriched in the course of my research by all that I have been introduced to and learned, particularly from Siegmund Forst. I count his friendship as this project's most exceptional reward. May we know each other many more years!

CER

Contents

A Personal Reminiscence

In 1949, for my brother's Bar Mitzvah, our California cousins sent him a new Passover Haggadah just published by the Shulsinger Brothers Linotyping and Publishing Company, 21 East 4th Street, New York City. Then a young art student, I was terribly impressed by the masterful illustrations, totally unlike any Jewish book illustrations I had ever seen. I remember turning back to the title page to see who made them—an artist I had never heard of—Siegmund Forst. The Shulsinger Haggadah, as we called it, immediately became my favorite Haggadah, which I read from at every Seder at my parents' home.

I remember being particularly fascinated by the full page scene of Pharoah's daughter finding the baby Moses, her slim waisted figure set off by the broad shoulders then in vogue (popularized by the Hollywood costume designer Adrian), surrounded by maid-servants whose simple but chic gowns and hairdos would pass today. Never before had I seen such a sophisticated rendering of the Biblical story.

But my favorite scene in the book was *Nishmat Kol Hai*—the soul of every living thing shall bless Thy Name—a fantasia of living creatures from land, sea and sky encircling a rapturous human figure, whose outstretched arms are flung towards the starry planet-studded skies. For me this painting captured the very essence of the prayer—the boundless energy and abundant richness of human existence granted us by the Creator of all living things.

Other images in the book were stirring depictions of life in the new State of Israel, only one year old when this Haggadah was published. To illustrate the blessing in the Grace After Meals *(Bentshing):* "Rebuild Jerusalem the holy city, in our days..." Forst painted an Israeli soldier, rifle in hand, standing guard in a field, while beside him, in the trench, another soldier, wearing tallit and tefillin is praying. Behind them, a construction crew works, while on a watchtower topped with a flag of the new state, sentries stand duty.

Half a century later, I am still enthralled by Forst's meticulous illustrations, a major reason why it is such a pleasure to present him with his first solo exhibition and catalogue. Although the artist's works have appeared in other YUM exhibitions: the Purim scene in *The Art of Celebration* (1986) was punctuated by his spectacular Megillat Esther,

and *Ashkenaz: The German Jewish Heritage* had a panel about him and his work as an example of a Viennese artist emigré, a critical mass of his oeuvre has never before been gathered together.

An oversight of such dimensions clearly had to be rectified. Here was an artist who quite literally had "changed the face" of Jewish publications in America, yet his name, despite half a century of publications produced in the tens of thousands, was unknown to all but a small group of admirers.

For several years the Museum sought funding for a Forst exhibition, but without success. In the meanwhile, the clock ticked on. And then, *B'heref ayin* - in the twinkling of an eye, our hopes were realized—an unexpected phone call on an otherwise unexceptional morning, from one of Forst's most devoted and modest admirers, offering to underwrite both exhibition and catalogue with one proviso—anonymity.

With this astonishing bit of good news, a true mitzvah—*Matan B'Seter*, a secret gift—the entire exhibition/catalogue mechanism was set in motion. I could not help but recall the Talmudic saying: יש קונה עולמו בשעה אחת A person can achieve immortality in one moment!

The Yeshiva University Museum extends its profound gratitude to the anonymous patron, whose magnanimous gesture has made possible this exhibition and catalogue, the long overdue public acknowledgement of the lifelong commitment to art in the service of Torah that has steadfastly marked the entire career of Siegmund Forst.

My reminiscences would not be complete without mention of two people who shared my enthusiasm for Forst's talent: Ita Aber, who was quick to respond to my invitation to visit the artist, and who compiled a preliminary survey of his work, and Cynthia Elyce Rubin, our guest curator, whose painstaking scholarly analysis of the artworks and many personal interviews with Mr. Forst enabled us to create this exhibition.

Sylvia Axelrod Herskowitz
December 1997

Siegmund Forst, Vienna, 1930s

About the Art of Writing

by Professor Dr. Max Eisler

excerpted from Wiener Jüdisches Familienblatt, September 1934

Ever since the awakening of Jewish nationalist sentiments, the question has been asked over and over, "Is there such a thing as Jewish Art?" There are many answers. In any case, those who wish for such an art answer affirmatively. And today they may be the majority. But this is not what counts. The difference of opinion on this issue may even be completely unimportant. What is important is to help this Jewish Art grow. And after all the labyrinthian turns of the recent past, a clear and certain way to move forward is now showing itself: the cultivation of Hebrew calligraphy. Because writing unites all the good qualities that make for a proper form of art.

First of all, there is tradition. Without tradition, there can be no real art. Tradition is the healthy root soil of every culture and so it is with the culture in art. Over the centuries the best strengths of a people have expressed themselves through art. If you want to arrive at a national expression, you have to follow tradition down to the pure and unassuming works of a people. None of these are purer than the works of the (Torah) scribe. Not only are they undoubtedly Jewish, moved by the impulses of the Jewish soul, but they are also immaculate in their end product.

Hebrew script has gone through a rich development in the millennia. Even different tasks it has set for itself—the writing of the scrolls of the law on parchment, the holy and scholarly scriptures, the prayers, the letters but also the carving of stones, the painting of walls with characters—all have helped to create different forms of script. The monumental, the decorative and the utilitarian take turns. The sojourns, moods, destinies and surroundings of the Jewish people have all exercised their influences. In spite of that, in its good times, script has always remained a righteous and noble craft, beginning with the supporting pad for the paper, the tools and accessories, with ink or color, derived as though adhering to law on these conditions and therefore complete in the letter, the word, the line, page or plate. In an order that is beautiful, vivid, or rigidly

structured, the individual joins itself to the whole, yields a rhythmic harmony, a pure work of art. The lofty thought that had become an image, the symbolic meaning, the magic of the signs having emerged from faraway origins of the people, made out of this work of art a Jewish one.

The renaissance of Hebrew script in our days is moving in this organic way. A sample from the hand of a young Viennese artist, Siegmund Forst, demonstrates this. In the school of Rudolph von Larisch, therefore trained by the master of modern calligraphy, Forst practices what he was taught; he writes. The letters are not traced and then filled in with Indian ink, rather they have come alive afresh from beautiful old models and are written as a whole. So one follows the other, well-formed and ordered, a pure and grand structure, of value by itself and also of a far-reaching and deep meaning. For by effort and direction, through morality and character, this simple activity shows faith, what should guide any other "higher" activity, if it is to be Jewish art.

Another piece of work by Forst, a "Mizrach," shows how his excellent and beautiful calligraphy joins with the image. For not only have letters been inserted in this woodcut but it is the same hand, the same sensibility, the same religious mind, that has created the images of the twelve Jewish tribes and arranged them with a very tender, yet strong sensibility for that living black and white space.

This is the beginning of the path that leads logically to an authentic, old-new Jewish art worthy to be noted and promoted by everyone. In Vienna, trained young calligraphers have been ready for years. Now it is up to all those who sometime, somehow commission work to keep those calligraphers busy. Every one of these works will inspire Jewish art and its creation.

Translated by Joelle Bollag

Max Eisler (1881–1937) was an art professor at the University of Vienna and wrote widely on various aspects of art, including Dutch art and synagogue architecture. Born into an assimilated family in Boskovice, Moravia, he became an Orthodox Jew as a young man and remained so for the rest of his life.

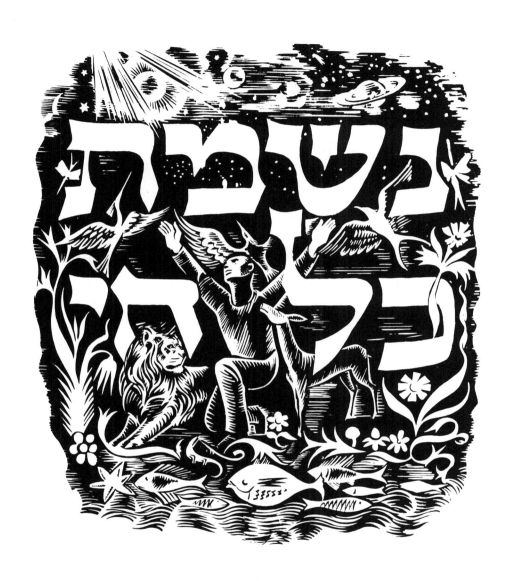

Nishmas: All Living Souls (CAT. NO. 3)

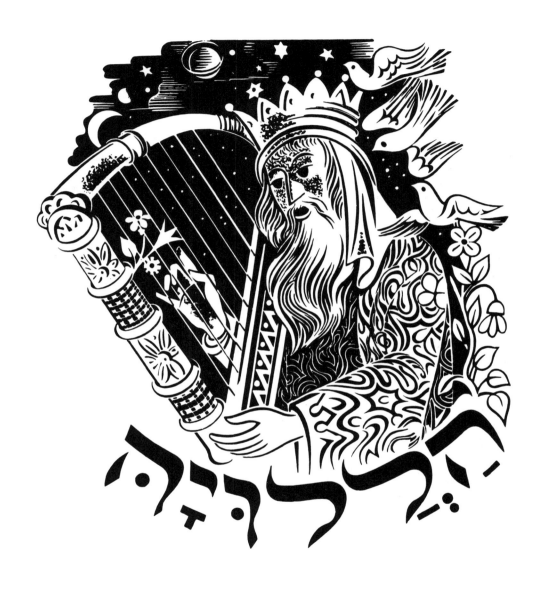

Hallelujah (CAT. NO. 105)

Siegmund Forst: A Lifetime in Arts & Letters

by Cynthia Elyce Rubin

Reading Max Eisler's 1934 column in *Wiener Jüdisches Familienblatt*,[1] one is struck by the author's confident optimism in both the past and the present and his sincere belief in the future. As he describes the stringent training Jewish [Torah] scribes had received for decades in Vienna, he compares it to Forst's work. "This is the beginning of the path that leads logically to an authentic, old-new Jewish art worthy to be noted and promoted by everyone," he concludes. Several years earlier, Eisler had commented on this very subject in *Aus der Kunstwelt*[2] *(From the World of Art)*, in which he wrote of his own attempts to improve the calligraphy or written artforms on Jewish textiles, sculpture, and books. He was only a little successful, but took note of the possibilities "in the schooled and pure hands" of Siegmund Forst how "the old script can show itself in its whole original magical power."[3]

Siegmund (Hebrew: Asher) Forst, the eldest of eight children, was born on August 31, 1904, to Isidore and Francesca in Vienna, Austria. Young Forst spent hours watching his father in fascination when he melted gold or repaired jewelry, as the senior Forst, a Polish immigrant, progressed through Vienna's guild system—from apprentice to fellow to master goldsmith. Upon completion of the required masterwork, he joined an established jeweler and then opened his own shop. The young Siegmund collected the used envelopes from bills and correspondence to the shop and practiced drawing on their reverse sides. Early years were spent in Vienna's eighth and ninth districts, but in 1920 the family moved to the second district's Novaragasse in the midst of the vibrant Jewish quarter.[4] Historically and culturally speaking, these were remarkable years.

At the outbreak of the First World War, a great change occurred within Viennese Jewish life as Jewish masses fled the Russian onslaught into Galicia, at that time part of the Austrian monarchy. Among the tens of thousands of refugees who streamed into Vienna were great luminaries of Torah and Hassidism. This mass exodus to Vienna had

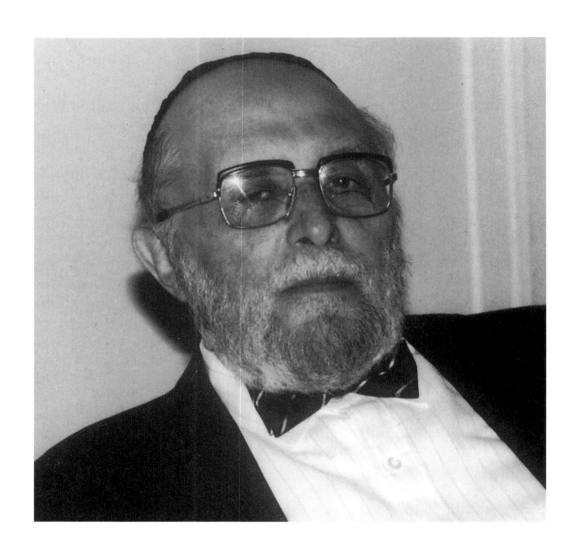

Siegmund Forst, 1997

a two-fold impact: on the one hand, it intensified the latent anti-Semitism of the Viennese population generated by the different appearance and life style of the new-comers, and, on the other hand, the new immigrants invigorated the spirit of the local Orthodox community.

In 1916, the long-ruling Emperor Franz Josef died and, within two years, his army and the grandeur of the Hapsburg family ceased to exist. After World War I, in September 1918 the proclamation of the Republic of German Austria by the provisional Assembly declared the end of the monarchy. In that same year, Forst witnessed the disappearance of Austria-Hungary entirely from the world map, and Vienna, formerly the capital and home of one third of the nation's population, found itself in the midst of a contracted Austria.

Mass production for an emerging middle-class market had already established a new consumer culture, as designers launched their own movements searching for forms and decorations appropriate to contemporary life. During this time of prodigious techno-logical and social growth and change, Vienna had been a strategic hub in the world of modern cultural thought. The music of Gustav Mahler and the twelve-tone system of Arnold Schönberg, the philosophy of Wittgenstein and the writings of Sigmund Freud, signified a "preponderance of Jews among innovative and pioneering scientists, writers and musicians."[5]

This was a period of great intellectual ferment when the design excesses of the Victorians were banished, and the ideals of individual creativity and craftsmanship were closely embraced. The earlier decorative arts of the Wiener Werkstätte, the Viennese Workshops, replaced the ornate curvilinearity of the nature-derived florid Jugendstil with a more rigid but simple symmetry and repetition. Designers like Koloman Moser and Josef Hoffmann discarded sensual, rounded curves for the black and white geo-metrics of a more modern age perfectly suited to the economy of the machine. The infu-sion of liberating ideas and crosscurrents helped to reshape the arts in the direction of twentieth century modernism. By means of changes involving the visual elements of line, color, shape, and subject matter pertaining to nationalism and industrial growth, the arts were gradually becoming an important aspect of modernization.

During this metamorphic period, Siegmund Forst was an exceptional, inquisitive young man growing up surrounded by the imperial architecture of a Baroque and Rococo Vienna. The city was a cosmopolitan world center for music, art, and literature,

which manifested itself in the Viennese institution of the coffee house, a meeting place and debating hall for everyone, especially artists. According to curator Kirk Varnedoe, "Vienna set itself apart [from other main European cities] by the eruption of talent in all the visual arts, and by the particular Viennese sensibility, the *Lebensgefühl* associated with those achievements."[6]

The Ringstrasse, a magnificent boulevard fashioned from the concept of *Gesamtkunstwerk* (total work of art), gave a sense of the city's undiminished greatness. With these grandiose public buildings and their accompanying formal gardens as a monumental backdrop, Forst was raised in a strictly traditional and observant family. He attended the *Volksschule, Bürgeschule* (today's *Hauptschule*) and *Handelsakademie*. Since there were no institutionalized facilities available for traditional Jewish studies, his education was complemented by tutors who regularly came to the home. Later on, he studied at the Mattersdorf Yeshiva.

Being a sensitive and curious boy, Forst was greatly attracted to the intensified form of traditional life style. He saw in the Eastern European Jew the prototype of authentic Judaism and for a time he became an adherent of the Hassidic way of life. Viewed from this vantage point, the worldly sophistication of Vienna seemed totally incompatible to Forst. He felt this dichotomy deeply and found it difficult, even in those young years, to wholly accept the two contrasting worlds. This internal conflict would echo throughout his life. While at the Yeshiva, he wrote articles criticizing certain aspects of Rabbi Samson Raphael Hirsch's philosophy as "compromising," which led to a controversy with Natan Birnbaum in the pages of *Jeshurun*, a prestigious Jewish-German journal of the time.

But when he chose a life's profession, he knew he wanted art. "Since I was a child, I could not stand an empty space—not a paper, not a wall," he remembers. Although they were not enthusiastic, his parents acquiesced to his desires,[7] and Forst enrolled in the *Graphische Lehr-und Versuchsanstalt, School of Graphic Arts*, a well-known art school of the day. There he studied not only drawing combined with practical application, but also graphics and advertising design. At that same time, he took several courses at the *Kunstakademie*, the Vienna State Academy of Art.

Forst remembers it as a bittersweet time. As the only student to wear a beard, which clearly labeled him a Jew, and having a pale countenance, he was taunted by his peers who called him "Jesus," a nickname of derision. In spite of this, Forst thrived during this period

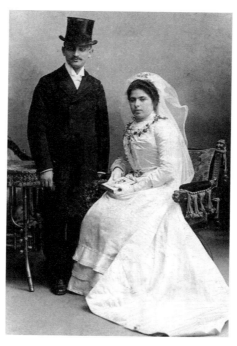

Forst's parents, Isidore and Francesca, Vienna, 1903

Forst's Report Card, School of Graphic Arts, Vienna, July 5, 1930 (CAT. NO. 141)

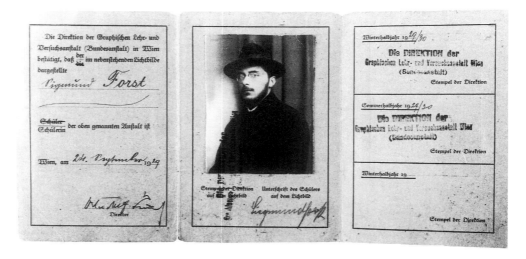

Forst's Student ID card, Vienna School of Graphic Arts, 1929–1930 (CAT. NO. 140)

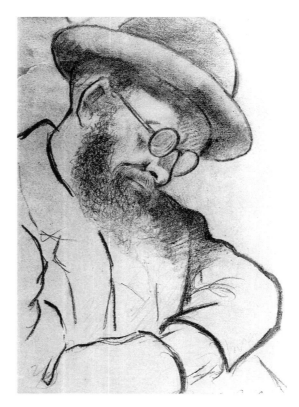

Portrait of a Friend, charcoal on paper, Vienna, 1937 (CAT. NO. 1)

of great creative drive and curiosity, mainly because of the influence of his calligraphy teacher, Rudolf von Larisch, described by Forst as "the old type of Austrian gentleman raised in a multinational monarchic empire—liberal, tactful, and broadminded."[8]

Under von Larisch's benevolent guidance, Forst recalls that he experienced no anti-Semitism, which, at the time, was endemic in the school and set him apart from his classmates. Von Larisch was well known in Vienna for having been instrumental in changing the face of ornamental lettering. In his groundbreaking publications, *Ueber Zierschriften im Dienste der Kunst (About Ornamental Letters in the Service of Art)* and the 1904 *Unterricht in Ornamentaler Schrift (Teaching Ornamental Lettering)*, he introduced such guiding principles for understanding letter forms as "an exercise that should not aim at models or norms, but rather as a means to ultimately overcome them."[9] Ultimately, this meant that letters have to be written, not drawn or constructed, and that of all the writing instruments available, the pointed steel pen was the worst since it interrupted a century-old tradition. (The quill pen remained the best.) Furthermore, it is not the individual form of the letter but rather the rhythmic joining together of the letters that is crucial. This, in turn, must be coordinated with the total visual impression. The position of the text in the space, the rhythm, the black and white relationship, even the character of the letter itself—all must be subjugated to the total harmony.

In his own introspective search, Forst did not always follow von Larisch's instructions:

> *Once I showed Larisch a letter design which was not written, but drawn and then filled in. I told him that it wasn't really what he had taught me, but he explained that it didn't matter.*
>
> *'What matters is that it is based on the lettering principles that I taught you.'[10]*

It was von Larisch who encouraged Forst to apply these lettering principles to Hebrew script, an idea that up until then had not occurred to the pious student. By this time, the elderly von Larisch, already in his seventies, could no longer write himself, but he walked among his students overseeing and correcting their work. Forst would follow his calligraphic devices on monumental designs, diplomas, works on parchment, book titles and Hebrew lettering combined with figurative illustration.

The second important influence on Forst was Arthur Weisz. Also an Orthodox Jew and of the same age, Weisz was a highly intelligent man, erudite in literature and philosophy—

a graphic artist who had studied in Paris. He introduced Forst to the history of world art, and both young men would visit museums to view the many different elements inherent in a wide range of artistic viewpoints. Weisz also introduced Forst to the writings of Swedish playwright and novelist August Strindberg and the philosophy of the German Friedrich Nietzsche, as well as to the art of Vincent Van Gogh and Paul Cézanne, thereby developing his sensibilities and opening up a whole new world for the young, impressionable Forst. Weisz also taught Forst the rudiments of his craft—the intricacies of fashioning a quill pen and how to make a woodcut. As the sole Orthodox graphic artist in the Jewish community at the time, Weisz was creating in Forst his own economic competitor. But it mattered little to the unselfish Weisz.[11] More importantly, he introduced Forst to Max Eisler, a noted professor and art historian at the University of Vienna, who wrote widely on such dissimilar topics as Dutch Art and synagogue architecture.

It was during the beginning years of Forst's self-employment that Eisler wrote the two articles cited earlier. Doubtless, he championed Forst's talent in an effort to direct commissions his way. In addition, he arranged Forst's first public exhibition—woodcuts of Jewish scenes of Hassidim exhibited together with the works of the painter, Max Slevogt, "neither wholly Impressionist nor wholly Expressionist,"[12] and the sculptor, George Ehrlich, in a group show of the *Hagenbund*, formerly the *Künstlerbund Hagen* (an Artists' Society that addressed itself to the younger generation in rebellion against the official world of the Ringstrasse). The festive opening, a heady experience for young Forst, drew much fanfare with many well-known dignitaries attending.

But it was commercial package design and advertising along with *Ketubbot* (marriage contracts), bookplates, B'nai B'rith honor scrolls illuminated with self-made ink and gold lettering, and varied private commissions that kept Forst busy, that is, until 1938. In May of that year, just two months after Hitler marched into Austria, Hermann Göring, Nazi politician and field marshal, assured Viennese citizenry that their beautiful city would soon be *judenrein* (free of Jews). Even though Jews were recognized as influential contributors to the professional and cultural life of Vienna, and legally entitled to acquire real estate, serve in the army and endow museums and orchestras and other creative enterprises, Jews were, after all, still Jews.[13] The anti-Semitism within Austrian society, never far from its surface, now had abundant, government-sanctioned opportunities to explode. After Kristallnacht on November 10, 1938, Jewish life, as all Vienna knew it, came to a swift and abrupt termination.

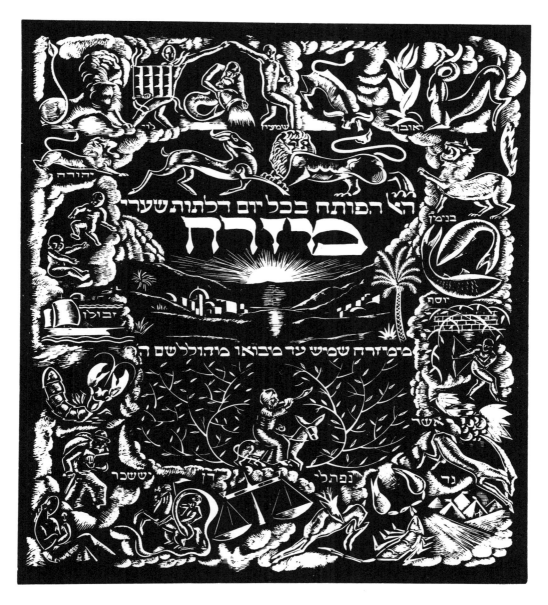

Mizrach, **Forst's first woodcut, Vienna, circa 1928 (CAT. NO. 75)**

Forst, now married to Erna (Ernestine Rumpler) and with two young daughters, lived in a modern studio apartment (the sole building on its street with an elevator), that served as his atelier, which he shared with another artist. One day his non-Jewish *Hausbesorger* (concierge) warned him that the Germans were about to launch a spontaneous house to house search, and she hid him and his family along with several others in an empty apartment. Lying on the floor, Forst heard the steps of the SS men accompanied by the concierge as they passed by the "so-called empty" apartment. Later, when the occupants emerged, they learned that many of their friends and neighbors had been rounded up and taken to Dachau. The small glass sign that had so proudly hung on the outside wall of 28 Ferdinandstrasse announcing "Siegmund Forst, Grafik-Studio/5ter Stock" was smashed, gone forever. On the other hand, Forst and his family remained intact.[14]

Afterwards, Forst's life resumed with a bizarre normality although art work became impossible. There were no jobs, nor any commissions. Since all the Jewish schools had been closed, Forst was able to glean a meager living by giving Hebrew and religious instruction. He spent his time searching telephone directories at the American Embassy in the hopes of finding a relative somewhere—in New York or Chicago. When his search was finally rewarded with an affidavit from an unknown distant aunt and uncle living in New York, Forst received an entry visa for the United States. After numerous trips to German authorities to prove, among other things, that he owed no taxes and had never been imprisoned, Forst and his family received the necessary exit papers. Later, on board the aptly named ship "President Roosevelt," he should have felt safe, but he always believed the Germans could still come after him. Upon entry to the ship, that sense of total oppressiveness even made him consider asking the captain for a place on board to hide his family, but in the end, he said nothing. During the trip, he remained apprehensive. At the first sighting of the Statue of Liberty, when the other passengers began to sing, Forst was too numb to muster any enthusiasm for the moment. On February 28, 1939, he had finally reached freedom, arriving in New York City with his wife, two daughters aged three and five, sixty dollars in his pocket, and "beset by fear, doubt, and uncertainty."[15]

With no recommendations or contacts, and with little knowledge of English, Forst's search for work, as he tells it, takes on an almost comical note. (At the time, it was not at all humorous.) After he received his first job at Viking Press to design a book jacket for *Mister Emanuel*, he realized he could not illustrate the jacket without knowing the

contents of the book. But he couldn't read English! What to do? He enlisted a young female relative to go to Viking Press with him where an editor explained the book's story line and the relative, in turn, translated it to Forst. After he had completed the project, and presented it to the art director who was satisfied with the work, Forst waited patiently to be paid. He did not understand that he had to send an invoice to the accounting department. Another time, he was asked to illustrate a barbecue, and when it became apparent that he had no idea what a barbecue was, he was promptly fired. According to Forst, his employment situation was one of constant flux; he would be hired and then he would be fired. The utter frustration of dealing with matters that he little understood and about which he could not communicate, drew him to the world of Jewish publishing. After all, he spoke German, Yiddish, and Hebrew; there was no difficulty communicating with the people involved in this segment of publishing. Out of necessity, he began what would ultimately become a life-long relationship with Jewish book arts on many different levels.

One of his earliest assignments was *The Haggada of Passover*, published by Professor Zevi Scharfstein in 1941 (illus. on p. 28). A Hebrew educator, journalist and publisher, Scharfstein devoted his life to Jewish education and continued a fruitful relationship with Forst through collaborations on numerous titles, particularly children's books, published by his company, Shilo. This Haggadah is of special importance because it not only established Forst's artistic career but may have been the first time in the history of Haggadah iconography that the artist personalized, with written text, the issue of modern destruction comparable to that of the ancient story.

> *Jewish Fate, which sways between suffering and redemption has grown to mighty proportions. With increases in suffering, the longing for redemption and the certainty of its coming have gathered strength.*
>
> *This is an old Jewish Book, one that speaks of such sorrow and hope. It now appears in contemporary dress, illustrated by one who himself has suffered the flames and escaped them. He was urged by the desire to vivify Jewish experience, as it finds expression in the words and pictures of the Haggada.[16]*

According to art historian Haya Friedberg, "Many modern Haggadah illuminators have found it difficult to resist the comparison between the process of liberation described in the ancient text and that of modern Jewish history."[17] The Holocaust provides a com-

The Haggada of Passover, ink on paper, 1941 (CAT. NOS. 4, 101)

pelling example, and Forst was the first to depict the Nazis as killers in Haggadah illustrations describing the Passover story. Forst's images assert a steadfast religious faith. In the very first illustration of this Haggadah, a man, holding the Torah close to his heart, stands on top of a revolving world globe engulfed in flames. With face lifted to the heavens, the entire image is surrounded by the Hebrew words, "Open ye the gates, that the righteous nation which keepeth the truth may enter in." Faith endures. Indeed, this is a prominent leitmotif throughout Forst's entire oeuvre of what he calls "Judeo centric" art. It is his concrete belief that the only way to overcome suffering is by spiritual means, a belief Forst has never renounced.

Among the many Haggadahs Forst illustrated, *The Haggadah of Passover* published in 1949 (Cat. no. 107) is another outstanding example. In this volume, we see images that in the history of the Haggadah had never before existed—an interjection of the Zionist element that Michel Shulsinger, the publisher, had promoted. In this edition, physical power is emphasized, not the spiritual power of the earlier text. Brilliant, colorful illustrations depict Jews as pioneers, glorified army soldiers and tireless workers. This new physical presence and strength came from the recent establishment of the State of Israel, which Forst "depicts as the beginning of the fulfillment of the hopes expressed in the text."[18] Emphasizing this attitude in the preface, Rabbi Dr. Sidney B. Hoenig, then Professor of Jewish History at Yeshiva University, wrote:

> *Of late there has been a tendency to get away from the medieval scenes and in the spirit of the present day to bring forth in bold emblem the imposing events of our own era—the resurrection of Israel as a nation and the return to its ancient homeland with the recognition of the United Nations of the world.*
>
> *The fulfillment of this dream is the motif of this new edition of the Haggadah.[19]*

Israel's Proclamation of Independence in Tel Aviv on May 14, 1948, is inserted in its entirety in this Haggadah. Its Hebrew version is surrounded by Forst's illustrated border of prefabricated housing, men on tractors, building sites, soldiers with rifle in hand and hoisting the Israeli flag. Pages of strong, dense color depict men, one wearing a tallit (prayer shawl) and tefillin (phylacteries) seemingly in the midst of fieldwork, beside a soldier holding a rifle. In the background, men push huge coils of wire; others hoe, and work with agricultural machinery. From an elevated vantage point, men stand

guard with the flag of Israel swaying in the breeze. (Plate no. 11) Women too are seen working in the fields with agricultural implements. These Zionist images are interspersed with Biblical images, figures from the past, that signify continuity and convey the importance of age-old wisdom. Another illustration depicts a view of a Jewish family seated around the Passover table. The grandparents may look European, but the children—the girl with brown bobbed hair and the young man with suit and tie—look like average American children. Elijah is coming through the door, opened by a typical American woman, to a room with few hints of time or place. Still, the substantial door, the painting with gilded frame on the wall, the heavy, silver candlestick on the table, and a silver wine cup for each person at the table, certainly signify a level of success indicative of life in America.

Through the decades, countless Forst editions and variations upon the Haggadah theme have been produced by publishers for various non-profit groups. This author has examined publications produced for Barton's chocolates—a staple on every Passover table—countless editions produced as gifts to friends and supporters of the General Israel Orphans' Home for Girls in Jerusalem, and variations for the Home of the Sages of Israel, among others. In *The Passover Haggadah* (Cat. no. 123) illustrated by children in the arts and crafts classes of the General Israel Orphans' Home in Jerusalem published without a date, the credit line reads, "The illustrations on the cover by Siegmund Forst," but one has only to glance at the opposite page to view a recognizable Forst illustration, and indeed, leafing through the little tome, there are many Forst illustrations that have been given no credit at all. One has the sense that Forst sold his drawings once, and then, through the years, publishers assembled, disassembled, and reassembled them into endless combinations.

During his long period of art production, Forst also illustrated many children's books. In the early years of American-Jewish children's books, many had been reprints of European literature, but educators and parents soon realized that children needed their own American texts. As a result of the decimation of European Jewry, first-generation post Holocaust Jews did not want to repeat the lives of their ancestors but with little overt anti-Semitism in America, neither did they want to assimilate into the secular culture. At this time American Jewish teachers sought to create a vibrant Jewish life, one that would keep the younger generation interested in Judaism. Forst found himself on the cusp of this need.

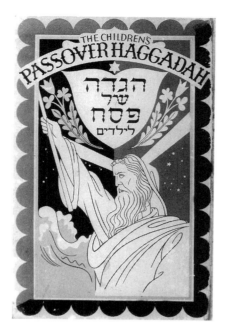

The Children's Passover Haggadah,
New York, 1945 (CAT. NO. 105)

The Children's Passover Haggadah,
New York, 1945 (CAT. NO. 106)

The Jingle-Book for Jewish Children, New York, 1947 (CAT. NO. 80)

Remaining deeply connected to strong religious roots, he was, at the same time, obliged to please his clients. Without any intent on Forst's part, many illustrations of the 1940s and 1950s bridged the gap to American society's mainstream values. Gone were the old-fashioned ghetto images of earlier texts. By means of bold, colorful and easy to understand illustrations that depicted proud Americanized children engaging in religious activities, Forst normalized ritual expression and connected with the next generation. He focused attention on Jewish values and ritual with entertaining and unaffected illustrations that unwittingly helped bring the post-World War II generation closer to its Jewish identity.

In his two early children's books, *The Jingle-Book for Jewish Children* (Cat. no. 80) and *Noah and the Animal Boat*, (Cat. no. 81) published in 1947 and 1948 respectively, both produced by Shilo with text by Ben-Ami Scharfstein, color and form become expressive and entertaining elements. The images in both books are simple in technique, direct, and render a poignant, perhaps even a naive quality. With bold primary colors and with flat images lacking perspective and of little fine modeling, these illustrations are reminiscent of folk art. On the other hand, since they are also skillfully designed, they display a refinement normally absent in folk art, and thus distinguish themselves. These books are aesthetically pleasing as well as culturally informative. Publishers seemed to attach an underlying importance in interesting young readers with congenial, joyful literature dealing with Jewish tradition and identity.[20] The two following examples from *The Jingle Book* demonstrate the light-hearted attitude of celebration with which Forst depicted deeply ingrained ideals of Jewish ritual and faith.

The illustration for Simhat Torah is marked by a two-colored, bold green and black image of a boy waving his flag on top of which sits an apple and a candle. His face beams with a broad grin. Life is secure and comfortable as the boy sings out:

> *I have my flag,*
> *My flag has an apple,*
> *My apple has a candle,*
> *My candle has a fire.*
> *My flag is happy,*
> *My apple is happy,*
> *My candle is happy,*
> *I am happy too.*

In another illustration entitled "Hebrew Too," a quizzical youngster is placed opposite the sages Abraham, Moses and King David. The underlying motif is that every Jew is descended from these three ancestors and takes part in an ancient continuum. This is the kind of image that the author and illustrator hoped would enthuse children and excite them to want to learn more about their heritage.

Abraham talked Hebrew,
Moses talked Hebrew,
King David talked Hebrew too.
I'm not Abraham,
I'm not Moses,
I'm not King David either.
But I know I'm not a fool.
I am going to go to school,
And before I will be through,
I'll be talking Hebrew too.

These are only two examples of a life committed to children's illustration, ranging from such disparate titles as *Let's Talk Hebrew* (1951), *The Book of Sabbath* (1962), *The Mice, the Fox, and the Cheese* (1975), *Lost in the Zoo on Erev Shabbos* (1983), an illustrated five-volume set of *The Little Midrash Says* (1986), and *My First Siddur* (1989). Throughout forty-odd years, Forst continued to use figures from the past as proof that even though the quality of everyday life may have become more certain for Jews in America—even though they participated in an unparalleled material prosperity—the basics of Jewish life and tradition remain the same. As post-World War II American Jews moved quickly "into the nation's social, cultural, and economic mainstream,"[21] the continuing appeal of Forst's juvenile illustration lies in the fact that no matter what American economic opportunities abound, the continuity of Judaism will sustain any urban or suburban despair.

Although personally consumed by deep reflection on the plight of modern man, Forst's commissioned illustrations depicted Jewish celebrations as lively and entertaining. In this way he not only created an interest in Jewish values but also helped to counteract powerful forces of assimilation by retaining an attachment from an audience that might otherwise have neglected it. At a time when Jewishness in America was undergoing great change—from that of immigrant to first-generation American to suburbanite—a time described by historian Jenna Weissman Joselit as "without parallel in modern Jewish history,"[22] Forst's art became a powerful cultural transmitter.

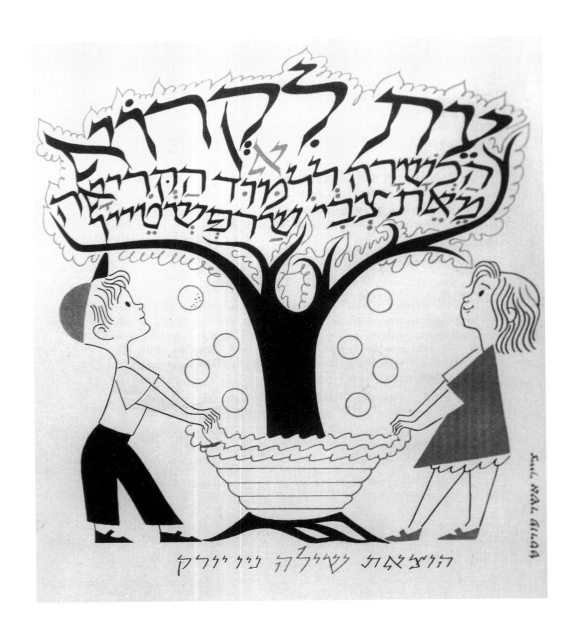

It's Time to Read Supplement, Shilo Press, 1951 (CAT. NO. 84)

As Jews found refuge in America, they desired to blend into contemporary American society hoping that inconspicuousness would eliminate the kind of events that had taken place in Europe. The need to feel secure in a new land was of paramount importance. Jewish identity declined; apathy reigned. To be modern was to be American. Forst's illustrations proved that one could be American and Jewish at the same time. His up-to-date depictions showed children, well-nourished, robust, comfortably clothed and smiling, celebrating Jewish holidays and learning Jewish texts. Their elders wore common everyday dress and displayed facial characteristics not unlike the born and bred Yankee.

This was a time when the burden of Jewish cultural continuity shifted from the cohesive community or shtetl, as it had been in Europe, to the individual family. Time-honored practices like the Sabbath and dietary laws often were regarded as archaic and their observance declined. Forst's own commitment as a bearer of the Torah, being an "authentic Jew" as he calls himself, was in conflict with much he witnessed in modern culture, as he explains:

> Deeply ingrained in my consciousness has been the desire to express not only the feeling of the deep gap which separates the two worlds of authentic Judaism and that of the temporal ever-changing scene of the surrounding culture, but also to give expression to the ongoing crisis which endangers authentic Judaism. In many of my illustrations in numerous Haggadahs, I show the arch-typical Jew surrounded by symbols of a decaying and depraved civilization. In this eternal isolation, surrounded by hatred and persecution, the Jew has still maintained his own self.
>
> The eternal dichotomy between the Jew and the world around him lies in Eternity vs. Modernity. Art can be regarded as a barometer for the temper of its time, following its development since its beginning to our times, as a search for self-identification and purpose. In the midst of all this stands the Jew in hope of redemption.[23]

While producing the "bread and butter" work of children's and ritual-book illustrations, Forst was also finding time to work on drawings and specifically woodcuts, in which his own ideology found expression. In this uncompromising medium, Forst was continuing to work in an artform honed in Vienna, one with its roots in Expressionism, a movement originating in Germany during the 1900s when young artists in Berlin, Munich and Dresden rejected classical and realist doctrine. Developing rapidly preceding and following

World War I, its novel approach toward art was that all nature was subordinated to emotional and visionary experience. Pre-occupied with the emotion evoked by an object or purely created from the artist's own consciousness, the Expressionist artist conveyed emotion by aesthetic form, thus basing art primarily on expression rather than representation—a conception that led to the emergence of twentieth-century art. In the Expressionist point of view, art should convey an aesthetic emotion, and the medium of choice used to achieve this end was the woodcut. "In the two chief homes of modernism, France and Germany, there is today hardly a painter or sculptor of note who does not on occasion express himself in the wood medium,"[24] revealed an author in a 1922 periodical.

At a time when Forst was perhaps being influenced by popular artforms, he turned to the woodcut medium and with works of superior draughtsmanship and great emotional depth, he displayed the essential "quality beyond the surface,"[25] that the original European Expressionists advocated. We find this emotional directness and strength over and over again in Forst's work. In *Burning Man* (1960)(illus. on p. 37, Cat. no. 61), the grieved man holds his ears in considerable pain, reminiscent of the Norwegian Edvard Munch's work, *The Cry-Der Schrei* (1893), which has become an icon of twentieth-century powerlessness. In Munch's work, as in Forst's work more than a half century later, there is a great sense of alienation. We see it in the horror-evoking shriek coming from the tortured being as it gives forth the "spasmodic clenched cry of Expressionism."[26] For Forst, it has to do with man's place on earth and his powerlessness over the will of God.

Because of the inherent nature of the medium, a woodcut depends on exact precision. In Forst's work, there is a precision of mass, of light and dark contrast and particularly, of that "form" which conveys emotion. For the Expressionist, this was part of a general upheaval which affected every sector of life in a modern nation. For Forst, it was more than that. He championed emotion and passion, too, but it was his profound feeling for "authentic" Judaism that yielded the majority of his subject matter. With elements of Expressionism, he took note of historic upheaval and despair and translated it into profound subjectivity. Certain motifs appear frequently in Forst's work, including Jonah or the Jew enclosed in the foreign body of the whale in the midst of a stormy sea and the Messiah hiding his face in primal pain. There are also several predominant themes which occur and reoccur throughout Forst's life work, among them the Jew confronted by evildoers in a hostile environment and the question, what does it mean to be a Jew?

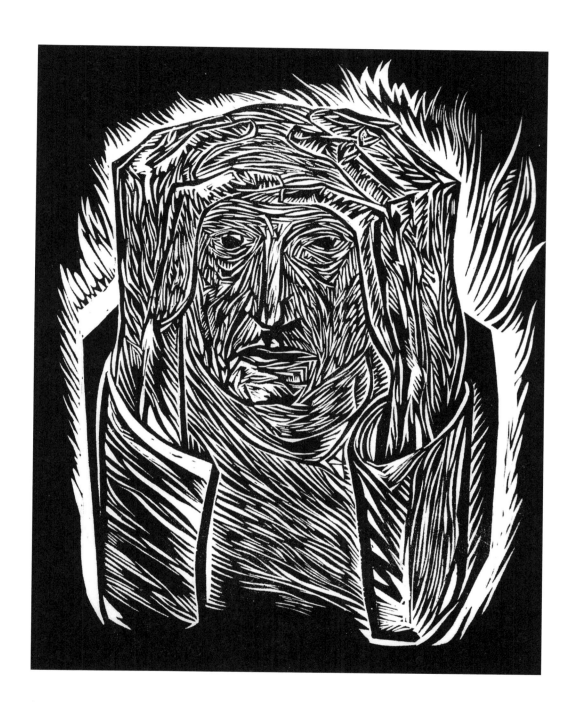

Burning Man, woodcut on paper, circa 1960, (CAT. NO. 61)

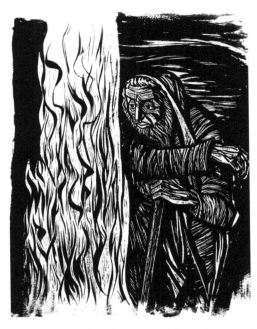

Moses Before the Burning Bush, ink on scratchboard, circa 1970 (CAT. NO. 39)

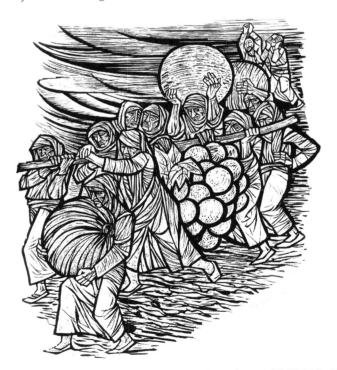

Meraglim (The Spies), ink on scratchboard, 1974 (CAT. NO. 41)

It is an age-old question, perhaps as old as the Jewish people themselves: What is our relationship to the culture and technological civilization in whose midst we find ourselves? On one hand we perceive ourselves as a corpus seperatum, *as an* am levadad yishkon. *On the other hand we are most vulnerably immersed, albeit not by our initial choice, in a dissenting world that threatens to dissolve our identity. Since the beginning of the emancipation era and our increasing contact with the surrounding culture this question has taken the form of an imminent crisis which puts the totality of our people in a state of constant confrontation.*[27]

There is another important element in Forst's work. As an artist, Forst was one among others who "not only is a Jew but feels and professes to be a Jew."[28] This was not an entirely new phenomenon. Genre scenes by Viennese artists, "redolent of local folklore and literary anecdote, and landscapes that expressed all the nostalgia of Viennese *Lieder* [songs] for country life,"[29] had appeared in the works of Jewish painters (such as Isidor Kaufmann, Jehuda Epstein and Mauricy Trebacz). They "achieved fame as chroniclers of Jewish life, translating into Jewish terms, the folkloristic regionalism of genre painting and creating for the prosperous Jewish middle-class of Vienna, a specific art, in terms of Jewish types and customs."[30] The term "genre" means ordinary people doing ordinary things. Although characteristics of Forst's style are completely different from the above named artists, the attitude that underlies their visual expressions, that of the concept of "a slice of life," is common to the varied works. In this context, Forst's woodcuts, such as "Chanukah," "The Lighting of the Menorah ,""At the Rebbe's *Tisch*" and "Hassidim" all comprise vignettes of the Jewish way of life.

Writing in his article, "Jewish Art and Its Problems," that there is no Jewish art, only Jewish artists, Forst defines the artistic impulse as "an interplay between the artist and his surrounding world, determined by its cultural temper."[31] He continues:

There is no demonstrable Jewish art form of the past. Archaelological finds show Canaanite, Assyrian, Phoenician, and later, Hellenic prototypes which can be identified as "Jewish" only by their inscriptions… What we have, from the earliest manuscript-illuminations to ritual artifacts are not free artistic creations, but…styles borrowed from Gothic and Renaissance models.[32]

Keeping in mind that Forst's own longevity embraces the Hapsburg monarchy, World War I, the collapse of the Austro-Hungarian Empire, the Holocaust, World War II, and the creation of the State of Israel—according to his own explanation of artistic

tendencies—his work may be interpreted as a synthesis of elements characteristic of the time period of his own life experience. In Forst's genre woodcuts, drawings and paintings, we also find emphasis on beauty in everyday religious ritual and life—in *"Tashlikh"*, when Ashkenazi Jews traditionally cast their sins into the water on the first day of Rosh Hashanah, in "Man with Lulav", (Cat. no. 47) the Sukkot ceremony of the Four Species, and in "Man with Chicken *(Kaporos)"* (Plate no. 9, Cat. no. 55) the traditional Yom Kippur atonement ritual.

When Forst arrived in America in the late 1930s, the arts were becoming one aspect of the country's progressive modernization. American potentiality was seen, not on windswept mountain tops as the Hudson River School had envisioned, but in the progressive and dynamic organization of the bustling city. Diversity and change were the fundamental characteristics of American art in the environment in which Forst had landed. But he chose to use painting and printmaking as his private catalyst to relate to the power of creation. In his woodcuts, the geometric quality of bold black and white, potent and immediate, is used as a means of expression. As a religious man, Forst distilled the complexities of life in the humble manner in which he lived, but he was able, at the same time, to bring Jewish children's literature and illustration into modernity. Since he concerned himself solely with the honesty and spontaneity of Biblical themes and everyday life, perhaps it is a purity of mind, shining through even his most commercial illustrations, that finds itself reflected in the ultimate power and grandeur of his works. According to Clive Bell, the English art critic, the worlds of art and religion can be inextricably related.

> *Both are bodies in which men try to capture and keep alive their shyest*
> *and most ethereal conception. The kingdom of neither is of this world.*
> *Rightly, therefore, do we regard art and religion as twin manifestations*
> *of the spirit.*[33]

Forst's contribution to Jewish-American visual arts also includes Hebrew ornamental lettering, the art of fine handwriting or penmanship, that had been practiced for thousands of years by the Torah scribe or *sofer*. By definition a wise and pious man, a *sofer's* training, learned from a master, necessitates a self-discipline, restrictive limits, and an exactness that ordinary calligraphy does not require. Calligraphy is artistic writing for its own sake—from the Greek *kalligraphia*—*kalli* meaning beautiful and *graphos* meaning writing. In calligraphy, the visual depiction itself is important, not the purpose or strict

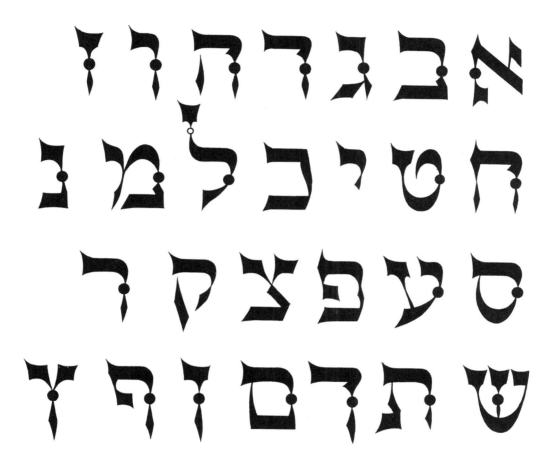

Siegmund Forst designed this alphabet in 1949.

adherence to tradition, as is the case with the Hebrew scribe. But with Forst, the two concepts: that of scribe/calligrapher and that of calligrapher, do not diametrically collide. As historian Karl Schwartz explained, the Jewish value system provides a vehicle to link calligraphy with the written word:

> The Jew was accustomed to using his eye for reading. Books, rather than nature, were his fount of knowledge. He saw the universe in letters—black and white; not in the motley reflection of colors. He read and he wrote. When he wanted to make a picture, he made notes of it, "described" it and "wrote" it down. And for this purpose, he used pencil and quill, not the brush.
>
> The Jew saw and felt graphically. For this reason he distinguished himself as calligrapher and also achieved success as a graphic artist.[34]

Called "one of the pioneers of the ornamental Hebrew letter in the U.S.,"[35] Forst put into practice the principles he had learned at school in Vienna from Professor Rudolf von Larisch, and combined them with the ancient Torah scribe's classical Ashkenazi letter displaying very pronounced and frequent thick and thin (shading) in its vertical quill stroke.

> The Ashkenazi type was employed in medieval Germany, central and northern France, England, and later, following the Jewish settlement eastward, in central and eastern Europe. It was strongly influenced by the character and the ductus of the Latin quill as a writing instrument. It is clearly manifested in the earliest dated codices of the late twelfth century onwards.[36]

The Latin calligraphy that Forst had learned in school became the foundation on which he built Hebrew lettering for book jackets, illuminated text in illustrations, gold-stamped lettering on prayerbooks, titles of periodicals, and many types of ephemera. Elevating the level of decorative lettering or graphics, he placed them on a par with those of America's secular world. He enhanced and beautified the Hebrew letter by adapting the European visual tradition influenced by the calligraphy of medieval manuscripts in which decorative borders and embellished letters enliven the text. In a unique combination of Hebrew text or letter with picture enriching the overall design, Forst adapted an Old World tradition to the New World. In both black and white and bright colors, he intertwined letter and figure—sometimes broken apart, sometimes reassembled into designs—to interject humor or decoration into a text.

Being a strictly observant Jew with a vision firmly rooted in the community around him, Forst often went beyond his own realm of experience and projected the image of the proud and confident American child in his children's books. As an illustrator and author, he helped launch the world of a modern lifestyle, all the time personally remaining within the value system of authentic Jewish principles. What the public today considers Forst's distinguished contributions to book arts are to the artist himself mainly the result of his "bread and butter" toil, rarely in unison with his personal viewpoint. It is interesting that Forst prefers to be remembered as an artist who used art as a medium to transmit his thoughts about the modern Jew living in a period of crisis in which he seems unable to free himself from a deep-seated anxiety and lack of meaningful focus.

Whereas most artists are known for certain paintings or works of art that hang in galleries or museums, Forst's production is viewed and read throughout the Jewish school, home, and synagogue. This remarkable man, both a thinker and a writer, has produced a treasure trove of writings filled with insights into his world view of art, culture, and religion. In addition, as an artist, he is a man of parts: an illustrator, a graphic artist, a designer of ritual objects, and a calligrapher, and, as such, he is singly responsible for many items of material culture that appear omnipresent throughout the Jewish household.

Examples include a prefabricated sukkah, the temporary dwelling needed in the celebration of Sukkot, designed for the Spero Foundation in the 1960s. Since it is appropriate to make the sukkah as beautiful as possible, Forst decorated it with fruits, birds and representations of the seven species that grow in Israel, all traditional motifs and themes. (Plate no. 15) His sukkah design, commercially produced first in heavy canvas, then in plastic, was used for years. Then as the sukkahs wore out, they were often discarded and yet, how many people realized that these admired items had been designed by Forst? In addition, Forst designed the Hebrew lettering for small plastic "Shalom" plaques, a donor gift for the General Israel Orphans' Home for Girls in Jerusalem, which were distributed by the thousands. Items of material culture such as these—the majority of them unsigned—have been in so many people's lives that one can never estimate Forst's total influence. To that end, he has also designed a Kiddush cup for sanctification over wine and a Seder plate to display Passover's essential ritual foods (Plate no. 17). He has drawn designs for Torah Ark curtains, commemorative medals for the State of Israel's 25th anniversary (1948-1973) and for the United States-Vietnam Peace Agreement of January 27, 1973, as well as commercial Ketubbot, most popular in the

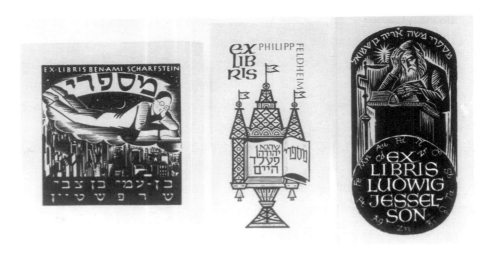

Selection of Bookplates, Ink on paper, circa 1955–1980 (CAT. NO. 45)

Siegmund Forst in his studio circa 1960

late 1960s and 1970s, bookplates, posters, stamps and booklets for charitable giveaways, book jackets and record covers. By means of all his many ephemeral works, as well as his ornamental gold-stamping on the covers and spines of prayerbooks, illustrations of different types, Passover Haggadahs, many holiday books, New Year's greeting cards, essays and writings, two illuminated Megillot on vellum for private collectors, and on and on, Forst has helped to forge a strong and positive foundation of Jewish identity. With his holiday books in particular, Forst has given the highest of values to ritual and traditional celebration, its unique and "special place within Jewish consciousness, which initially, helped forge the nation, establish its relationship with God and define its purpose."[37]

Who can say which work is Forst's most artistic—his most memorable—his most influential? Today at the age of 93, because of impaired eyesight, Forst's lifetime of production has finally concluded. His prolific life oeuvre, concentrating on themes that deeply affect him, is valued not only as part of a continuum in religious artistic tradition but also as the trailblazing agent[38] that brought Jewish illustration and calligraphy into modernity. Enriching everyone's life, his legacy will be handed down through future generations. A man who has devoted a lifetime to Torah and to art, Forst's contribution to Jewish-American popular culture, its "arts & letters" on many different levels, is doubtless long overdue for public appraisal, and with it, an undisputed enthusiastic acclaim.

Cynthia Elyce Rubin *is a curator and writer living in New York City. She has organized many exhibitions including Southern Folk Art; Pennsylvania Germans: Decorative Arts; Child's Play: the History of American Toys; and Swiss Folk Art: Celebrating America's Roots. Her publications are: Shaker Miniature Furniture, Mission Furniture, Southern Folk Art, ABC Americana from the National Gallery of Art, and Larger than Life: the American Tall-Tale postcard, 1905–1915.*

ENDNOTES

1. Max Eisler, "Von der Kunst des Schreibens," *Wiener Jüdisches Familienblatt* 11 (September 1934): p. 10.

2. Max Eisler, "Aus der Kunstwelt/Der Schreiber Siegmund Forst," *Menorah: Jüdisches Familienblatt für Wissenschaft/Kunst und Literatur* 11/12 (November/December 1932): p. 451.

3. On a personal note, reading between the lines, the author tried to find within this optimistic text an indication of the catastrophe soon to darken Europe that would wipe out the entire population of the Viennese Jewish community.

4. For a complete discussion of this topic, read Ruth Berkermann, *Die Mazzesinsel: Juden in der Wiener Leopoldstadt 1918–1938* (Vienna and Munich: Löcker Verlag, 1984).

5. Robert Waissenberger, editor, *Vienna 1890–1920* (New York: Rizzoli, 1984), p. 107.

6. Kirk Varnedoe, *Vienna 1900: Art Architecture & Design*, (New York: The Museum of Modern Art, 1986), p. 219.

7. Forst's father was adamant that Siegmund could not attend university since it might lead him astray from his Orthodox path. The elder Forst really wanted Siegmund to go into the diamond or jewelry business, but soon realized that he would not make a good businessman.

8. Siegmund Forst, "Siegmund Forst Remembers Rudolf von Larisch," *Letter Arts Review* 1, vol. 12 (1995): pp. 13–14.

9. Friedrich Neugebauer, "Rudolf von Larisch," translated by Siegmund Forst, *Letter Arts Review* 1, vol. 12 (1995): pp.8–16.

10. "Siegmund Forst Remembers Rudolf von Larisch," p. 13.

11. Forst still feels a debt of gratitude toward Weisz for his countless generous acts.

12. "His Baroque restlessness of form, his melodramatic interests and brilliant narrative gift, put him in a special position. *"Bernard S. Myers, The German Expressionists: A Generation in Revolt* (New York: Frederick A. Praeger, 1957), p. 20.

13. *Forced to Flee: The Legacy of Austrian Jewish Emigrés*, catalogue for A Joint Exhibit of the Leo Baeck Institute and the Austrian Cultural Institute, June-September 1997 (New York: Leo Baeck Institute, 1997), p. 5.

14. Interview with Siegmund Forst, 4 August, 1997, Brooklyn, New York. When asked about the action of this woman, Frau Schipetz, Forst explained that she had always been an anti-Semite but a personal experience seems to have changed her attitude. Her husband had been employed by a Jewish owned bank and when it was taken over by the Nazis, he lost his job. Somehow this unpleasant experience with the new boss transformed the couple's attitude, and they actually helped Forst and his family. When Forst later received exit papers, the husband, a skilled carpenter, built a large wooden box for the Forst family to store their belongings for the trip to America, and the Austrian couple even stuffed Forst's pockets with cigarettes as he departed on the train to Hamburg. To this day, Forst regrets that he lost contact with this couple who saved him and his family.

15. Ibid.

16. Abraham Regelson, translator, *The Haggada of Passover* (New York: Zevi Scharfstein, 1941), p. 1.

17. Haya Friedberg, "The Unwritten Message-Visual Commentary in Twentieth-Century Haggadah Illustration," *Jewish Art* Vol. 16/17 (1990 1991): p. 157.

18. Ibid., p. 167.

19. *The Haggadah of Passover*, Preface to "Introductory Notes and Supplement," (New York: Shulsinger Bros., 1950), 2nd edition, n.p.

20. For a more complete discussion of Jewish children's literature, read *Letters Dipped in Honey: Jewish Children's Literature from the Moldovan Family Collection,* an exhibition organized by Yeshiva University Museum, (New York, Yeshiva University Museum, 1995).

21. Edward S. Shapiro, *A Time for Healing: American Jewry since World War II* (Baltimore and London: The Johns Hopkins University Press, 1992), p. 28

22. Jenna Weissman Joselit, *The Wonders of America: Reinventing Jewish Culture 1880-1950* (New York: Hill and Wang, 1994), p. 7.

23. Letter from Benjamin Forst to Cynthia Elyce Rubin, (dictated to Benjamin Forst by Siegmund Forst), 31 August, 1997.

24. Sheldon Cheney, "German Expressionism in Wood," *International Studio* (June 1922), p. 249.

25. Ibid.

26. Myers, *The German Expressionists*, p. 31.

27. Siegmund Forst, "Falling Idols," *Jewish Action, The Magazine of the Orthodox Union*, Vol. 31 No, 1 (Winter 1990–1991): p. 82.

28. Karl Schwarz, *Jewish Artists of the 19th and 20th centuries* (Freeport, New York: Books for Libraries Press, 1970 reprint of 1949 edition), p. 102.

29. Cecil Roth, editor, *Jewish Art: An Illustrated History* (New York and Tel Aviv: McGraw-Hill Book Company, and P.E.C. Press, Ltd., 1961), p. 618.

30. Ibid., p. 619.

31. Siegmund Forst, "Jewish Art and Its Problems," *Jewish Action, The Magazine of the Orthodox Union*, Vol. 54 No.2, (Winter 1993): p. 62.

32. Ibid., p. 64.

33. Clive Bell, Art (New York: Perigee Books, 1981), p. 63.

34. Schwartz, *Jewish Artists of the 19th and 20th centuries*, p. 8.

35. Leila Avrin,"Modern Hebrew Calligraphy," *Encyclopaedia Judaica Year Book 1986/7*, p. 98

36. Malachi Beit-Arié, "Palaeographical Identification of Hebrew Manuscripts: Methodology and Practice," *Jewish Art* (Jerusalem: Center for Jewish Art of The Hebrew University, 1987), p. 19.

37. Lesli Koppelman Ross, *Celebrate: The Complete Jewish Holidays Handbook* (Northvale, New Jersey: Jason Aronson Inc., 1994), p. xvii.

38. This was, of course, never Forst's intention.

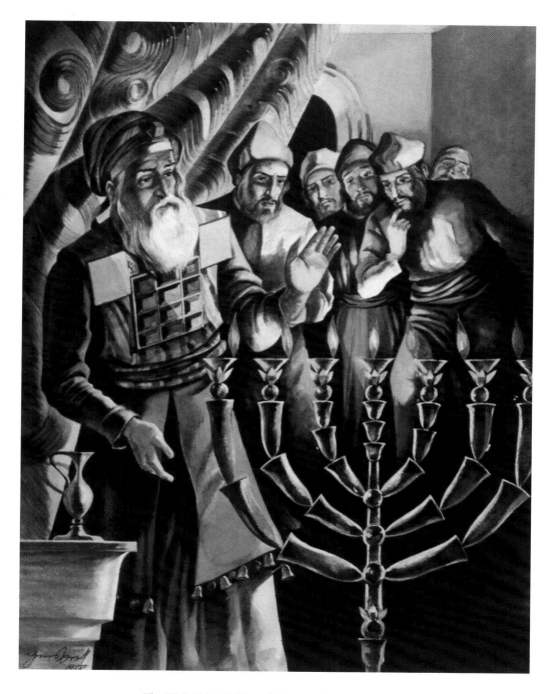

The High Priest Lights the Menorah (CAT. NO. 14)
PLATE NO. 1

Megillat Esther (CAT. NO. 33)
PLATE NO. 3

Sacrifice of Issac (CAT. NO. 19)
PLATE NO. 2

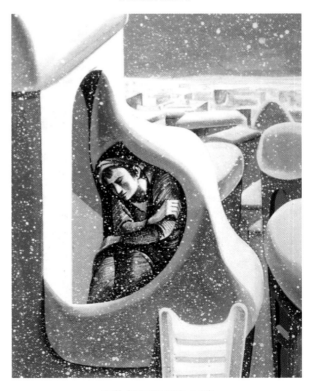

Hillel (CAT. NO. 145)
PLATE NO. 4

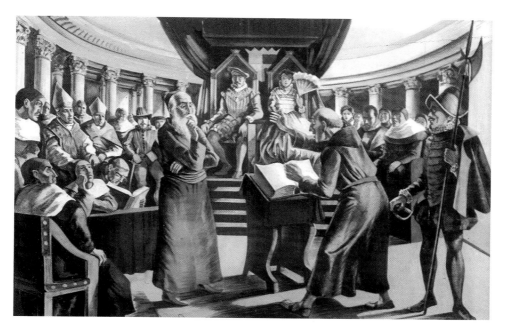

Ramban Debate (CAT. NO. 48)
PLATE NO. 5

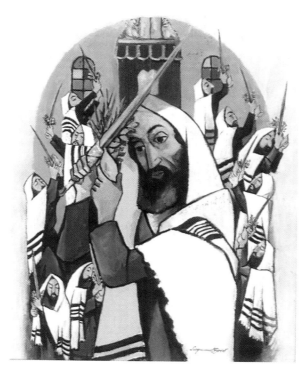

The Lulav (CAT. NO. 50)
PLATE NO. 6

51

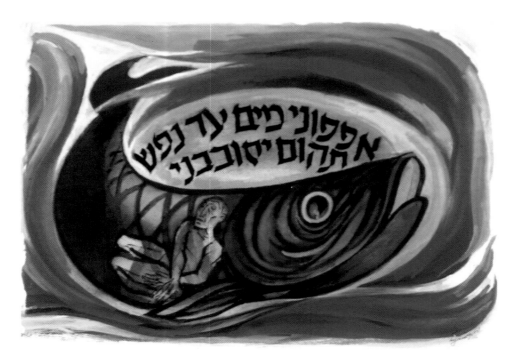

Jonah (CAT. NO. 53)
PLATE NO. 7

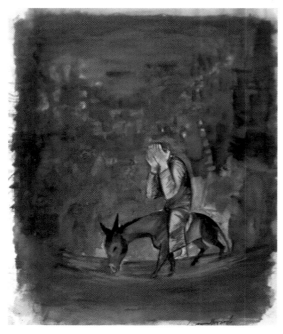

Messiah Coming (unfinished) (CAT. NO. 54)
PLATE NO. 8

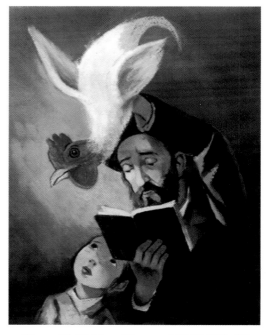

Man with Chicken (Kaporos) (CAT. NO. 55)
PLATE NO. 9

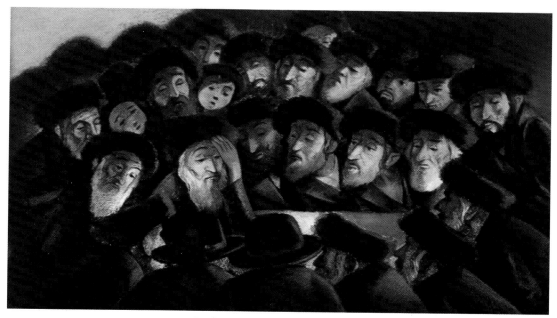

At the Rebbe's Tisch (CAT. NO. 56)
PLATE NO. 10

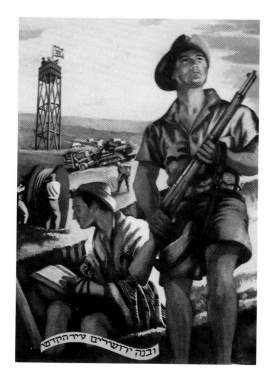
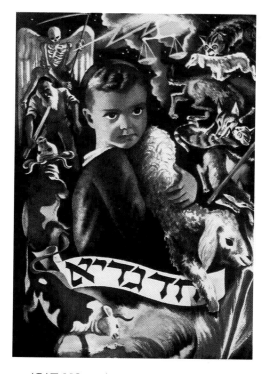

The Haggadah of Passover (CAT. NO. 107)
PLATE NOS. 11, 12

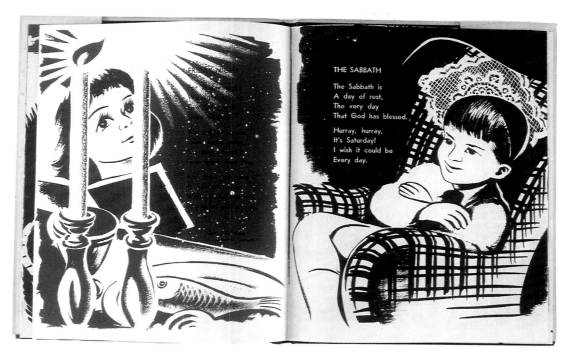

The Jingle-Book for Jewish Children (CAT. NO. 80)
PLATE NO. 13

Noah and the Animal Boat (CAT. NO. 81)
PLATE NO. 14

Sukkah Decoration (Detail) **(CAT. NO. 153)**
PLATE NO. 15

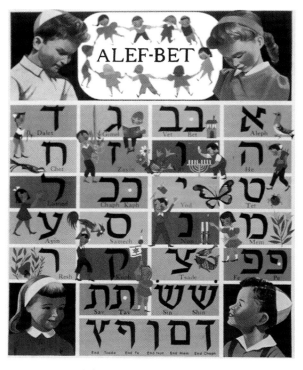

Alef-Bet Chart **(CAT. NO. 76)**
PLATE NO. 16

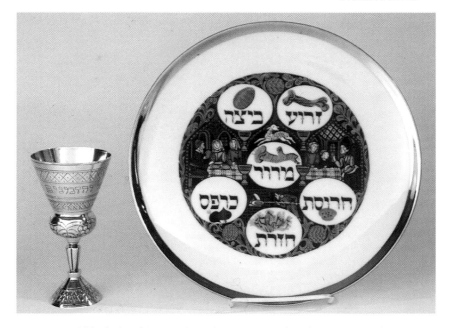

Kiddush Cup **(CAT. NO. 147),** *Passover Plate* **(CAT. NO. 154)**
PLATE NO. 17

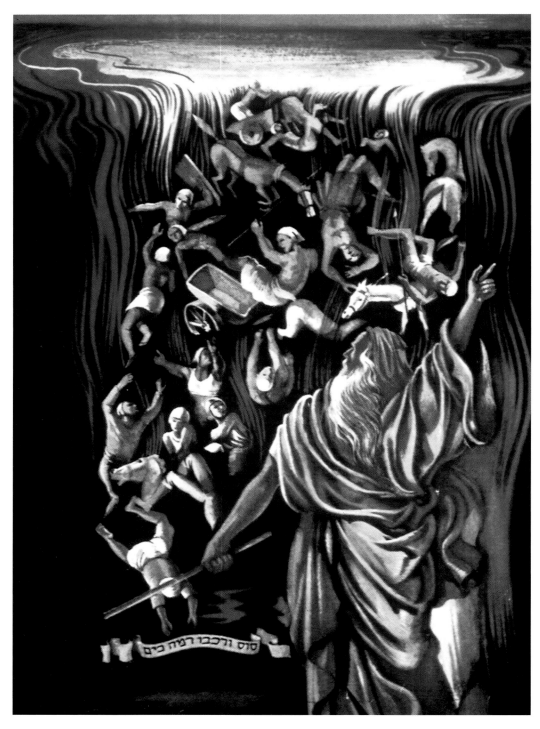

סוס ורכבו רמה בים

The Haggadah of Passover (CAT. NO. 107)
PLATE NO. 18

Exhibition Checklist

All measurements are in inches, height preceding width,
and indicate image size only. No measurements are given for books.
Asterisks indicate illustrated works.

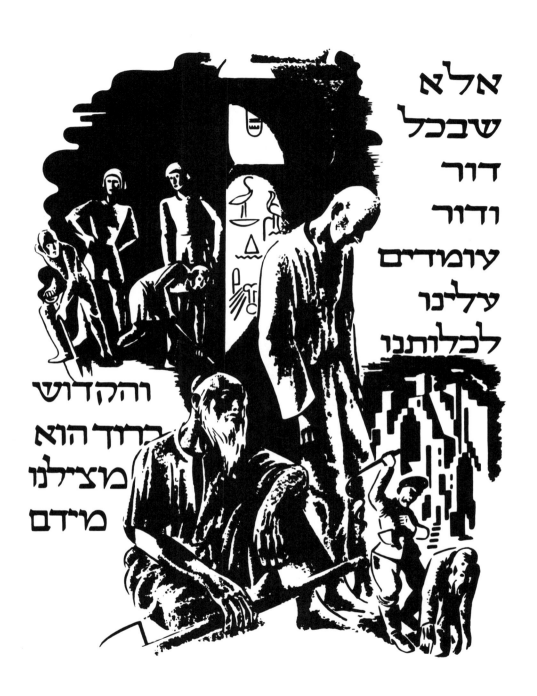

אלא
שבכל
דור
ודור
עומדים
עלינו
לכלותנו

והקדוש
ברוך הוא
מצילנו
מידם

In every generation… (CAT. NO. 105)

Drawings and Paintings

*** 1. *Portrait of a Friend***

Charcoal on paper, 1937
11 3/4" x 7 5/8"

Collection of Siegmund Forst

Illus. on p. 22

One of Forst's early drawings in Vienna; he sketched this portrait of a friend napping.

2. *Ketubbah (Marriage Contract)*

Groom: Yaakov Tzvi, son of Moshe Yehudah
Bride: Riva, daughter of Pinchas
Vienna, 1938
Ink on paper
8 3/4" x 9 3/4"

Collection of Irene Neurath

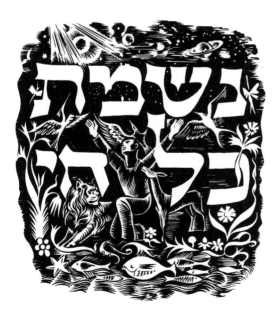

CAT. NO. 3

*** 3. *Hagaddah illustration: Nishmas "All Living Souls"***

Ink on paper, 1941
8 5/8" x 7 3/4"

Collection of Siegmund Forst

Illus. on p. 15

"The souls of every living thing shall bless thy Name." (Morning service for Sabbath and Festivals) Forst's handling of the images intertwined with the Hebrew letters gives a balanced and harmonious aspect to this visual commentary on the text.

*** 4. *Hagaddah illustration: "Jew with Cup of Redemptive Hope"***

Ink on paper, 1941
9 1/8" x 8 1/8"

Collection of Siegmund Forst

Illus. on p. 28

See also Cat. No. 101

In this illustration for Forst's first Hagaddah published in America, by Zevi Scharfstein, Shilo Press, the Jew holds the cup of redemptive hope as he is encircled by the symbols of his tormentors from the Roman soldier to the Nazi militia. Its circular composition connects the endless cycle of oppression. Nonetheless, hope and faith are Forst's two main themes, "illustrated by one who himself suffered the flames and escaped them."

5. *Jew in the New World*

Watercolor on paper, 1942
17" x 12 3/8"

Collection of Manya Fink

* 6. *Under the Sword*

Ink on paper, circa 1942
11 1/4" x 6 1/2"

Collection of Siegmund Forst

This is an illustration for a propaganda pamphlet directed at American Jews to alert them to the atrocities taking place in Europe. The focal point of this work is the blade, its handle decorated with Nazi insignia. Its point directs the viewer's eye to the oppressed Jewish population below. Encircled and with arms around each other, they are holding on for dear life, in quite the literal sense. Forst seems to be making the point that as long as some Jews are oppressed, none can be truly free. To emphasize collective responsibility in bringing all Jews together, a man's arms extend around the circular body of people.

* 7. *Wounded Man*
(Illustration for The Five Megilloth)

Gouache and ink on paper, 1950
13 1/2" x 9 3/8"

Collection of Siegmund Forst

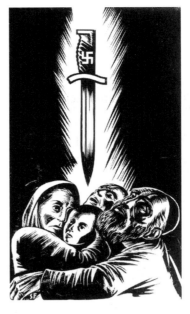

CAT. NO. 6

8. *Bostanai (incomplete manuscript)*
Illustrations for cover page and six pages

Watercolor on paper, circa 1950
11 1/4" x 8"

Collection of Siegmund Forst

9. *Lamentations*
(Illustrations for The Five Megilloth)

Charcoal and wash on paper, 1950
13 1/2" x 9 3/8"

Collection of Siegmund Forst

* 10. *Jew Surrounded by Malicious People*
(unfinished)

Ink on paper, circa 1955
9 5/8" x 7 7/8"

Collection of Siegmund Forst

Illus. on p. 61

In many of Forst's illustrations, he depicts the archetype Jew surrounded by symbols of a decaying and depraved civilization. This eternal isolation, in which the Jew is surrounded by hatred and persecution but still maintains a sense of self, is one of Forst's primary themes.

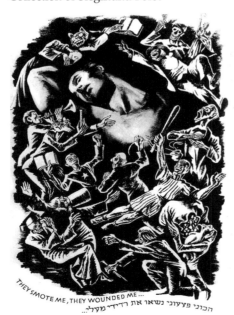

THEY SMOTE ME, THEY WOUNDED ME...

הכוני פצעוני נשאו את רדידי מעלי...

CAT. NO. 7

Illustrations for The Book of Hanukkah (1958)

Watercolors, 1957
Collection of William Loewy

11. Simon the Just and Alexander the Great
13 1/2" x 12 1/4"

12. Heliodorus
13 1/2" x 10"

13. The Lawless Built a Stadium
12" x 9 1/2"

* *14. The High Priest Lights the Menorah*
11 3/4" x 8 3/4"
Plate No. 1, p. 49

15. They Carried Rustling Palm Tree Branches
10 3/4" x 12 1/2"

16. Eliazar Saw It First
13 1/4" x 10"

17. Street Scene in Jerusalem
10 3/4" x 13 1/2"

18. Wedding in Jerusalem
12" x 9 1/4"

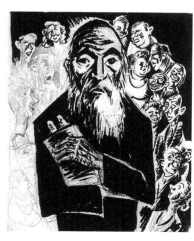

CAT. NO. 10

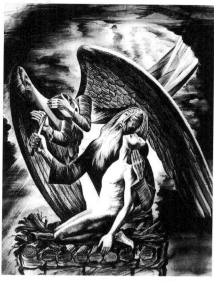

CAT. NO. 19

Illustrations for the Bible (unpublished)

Wash drawings, 1957
Collection of William Loewy

* *19. Sacrifice of Isaac*
14" x 9 7/8"
Plate No. 2, p. 50

The drama inherent in the story of the Divine command to Abraham to sacrifice his son, Isaac, is apparent in this drawing. An angel covers his face as Abraham lifts the knife. In the body language of Isaac, with face uplifted to Heaven, we know that he too stands up to this test. With body poised to receive the blade, he does not cringe in fear. The angel's wings serve as a powerful visual archway to emphasize the moment of drama. Using an unusual compositional formula, Forst focuses on a single act that relates not just to a transitory moment but to all eternity.

20. Noah
12 5/8" x 9 7/8"

* *21. Devorim (The Book of Deuteronomy)*
13 3/8" x 9 1/8"

The attitude and stance of Moses convey both immediacy and grandeur. The spontaneity of stroke is seen in the scarf wafting in a breeze. Moses' face displays grief and suffering. His spot on the mountain and the textural suggestion of craggy rock formations emphasize the monumental task of leading the Jewish people out of slavery to Revelation at Mt. Sinai. The compositional elements of the diagonal mountainside and the elbow shaped scarf are in opposition. With this composition and fine modelling, Forst's work yields subtleties absent in other works. In Moses' long farewell speech to the people, he reviews Jewish history in order to impress upon them the obligation to fulfill the *mitzvot* (commandments).

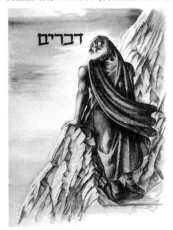

CAT. NO. 21

22. Joshua
12 7/8" x 9 7/8"

* *23. Daniel*
14 1/8" x 9 1/8"

Daniel, the hero of the Biblical book bearing his name, is famous for surviving the lions among whom he was cast by the Babylonian King, Nebuchadnezar. In one of Daniel's previous visions the kingdom of Babylonia is represented as a lion with eagle's wings. Here the lions, symbol of power and strength, are not ferocious but sleep quietly and rest comfortably beside Daniel.

24. Samuel Recovering the Ark from the Philistines
14" x 8 5/8"

25. Meraglim (the Spies)
11 7/8" x 9 3/8"

26. Samuel I
11 7/8" x 9 3/8"

27. Jonah
12 1/4" x 9 3/8"

28. Tehilim (Psalms)
12 1/4" x 9"

29. Elisha and Eliyahu
12 1/2" x 9 1/4"

30. Vayikra (The Book of Leviticus)
12 7/8" x 10 1/8"

31. Job and His Friends
Wash drawing on paper, circa 1957
11 3/4" x 8 3/4"

Collection of William Loewy

32. Moses the Law Giver
Ink on paper, circa 1960
25 3/4" x 18 3/4"

Collection of Siegmund Forst

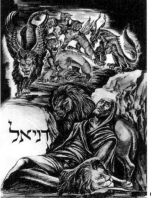

CAT. NO. 23

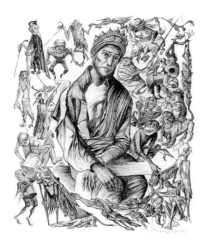

CAT. NO. 35

* 33. *Megillat Esther (Scroll of Esther)*

Ink and illumination on parchment, circa 1960
18 1/4" x 71 1/16"
Collection of Rena Kronenthal

Plate No. 3, p. 50

The word Megillah comes from the Hebrew *galal*, meaning "to roll." Esther's account of the Purim story, sent to the Men of the Great Assembly in Jerusalem, was written in a letter in the form of a scroll. Because of this, the Megillah is written on parchment and then rolled.

The names of Haman's ten sons are read in one breath simultaneously since they are all considered equal to their father in notoriety. In the scroll itself the ten names are listed in a column, separated from one another rather than forming the usual block of letters. This visual departure from the norm is explained by the Talmud: "If the names of ten sons were printed one after another like bricks with no gaps between them, together they would form a structure, a unit. But forming a vertical column of bricks, a weak structure, the house of Haman will inevitably fall, never to rise again." (Babylonian Talmud, Meg. 16b., Quoted in *Purim: The Face and The Mask*, Yeshiva University Museum, 1979) Forst's humor shines through in his image of the men hanging from a flagpole. He depicts a vulture, a bird of prey that feeds on carrion, on the very top of the flagpole, but it is a very benign rendition of this predatory bird.

34. Ketubbah (Marriage Contract)

Groom: Israel Shalom Yosef,
son of Mordekhai Shlomo;
Bride: Nehama Neha,
daughter of Yosef Haim
New York, 1965
Ink and watercolor on paper
17" x 11 3/4"

Collection of Mr. and Mrs. Israel Friedman

* 35. *Koheles (Ecclesiastes)–Solomon the King*

Ink on paper, circa 1967
11 1/2" x 9 1/4"

Collection of Siegmund Forst

Forst's art transmits how scripture takes on a powerful meaning in modern times. King Solomon wearing his crown and with torn clothes does not look the part of the king, nor is his demeanor very royal. His is not a proud legacy for he is a broken man, besieged by the symbolic renditions of his royal subjects. Forst's inspiration for this work was Ecclesiastes: to amass wealth selfishly, bemoans King Solomon, is "futility of futilities." We see the symbol of one fish eating another. A lady is drinking. On the bottom is Freud, a skeleton covered with a mantel, his admirers flocking after him. He is on crutches, an artifical means of movement. How the world has overestimated the role that psychoanalysis plays! Freud is for Forst an example of how relativism makes truths relative. According to Freud, ethical behavior is judged only in relation to its circumstances. Thus believes Forst: this is a society in which the blind lead the blind, as depicted in the upper left corner.

* 36. *Echad (One)*

Ink and gouache on paper, circa 1967
8 3/4" x 5 1/2"

Collection of Siegmund Forst

As the title page for *Within Thy Hand: My Poem Book of Prayers*, a representation of the Ten Commandments is used as a graphic device for inviting the viewer to enter the world of the text.

The empty tablets function as a picture frame isolating the text in the book's title, and drawing attention to it. It is interesting that Forst depicted heaven and the waters as an upper world and a lower world, but that he allowed the waters to permeate the lower portion of the tablets. Forst's compositional formula is unexpected and as such gives tension to the entire design.

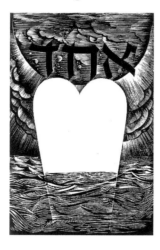

CAT. NO. 36

37. Design for Magazine Cover for Yeshiva Chasam Sofer
Watercolor on paper, circa 1967
9 3/4" x 12 1/8"
Collection of Siegmund Forst

38. Ketubbah
Groom: Rafael, son of Shimon
Bride: Rena, daughter of Mikhal Yehoshua
Brooklyn, New York, 1968
Ink and watercolor on vellum
17" x 12"
Collection of Mrs. Rena Kronenthal

* *39. Moses Before the Burning Bush*
Ink on scratchboard, circa 1970
12 1/2" x 10"
Collection of Siegmund Forst
Illus. on p. 38

40. Moses on Mount Sinai
Ink on scratchboard, 1974
13 5/8" x 10 1/4"
Collection of William Loewy

* *41. Meraglim (The Spies)*
Ink on scratchboard, 1974
13 1/2" x 10 1/2"
Collection of William Loewy
Illus. on p. 38

42. Creation
Ink on scratchboard, 1974
13 1/4" x 10 1/8"
Collection of William Loewy

43. Deuteronomy
Ink on scratchboard, 1974
13 1/8" x 10"
Collection of William Loewy

44. Man with Chicken
Charcoal drawing on paper, circa 1975
13 3/8" x 10 1/8"
Collection of Siegmund Forst

* *45. Selection of Bookplates*
Ink on paper, circa 1955–1980
5 1/2" high, each
Collection of Siegmund Forst
Illus. on p. 44

Forst's skill as a calligrapher who interweaves lettering with visual image is apparent in these examples of bookplates commissioned by individuals. Humor is also demonstrated as Ben-Ami Scharfstein, the prolific author of children's books, is seen propped on a cloud reading with the skyscrapers of New York City on view below. A spice box forms the distinctive outline for Philipp Feldheim's bookplate, and Ludwig Jesselson's bookplate depicts a scholar reading a holy book by candlelight.

46. *Designs for Ark, Title and Bookplates*
Mixed media on paper, 1950–1980
Collection of Siegmund Forst

47. *Man with Lulav*
Pastel on paper, circa 1992
11" x 15 1/4"
Collection of Siegmund Forst

* 48. *Ramban Debate*
Watercolor on paper, 1992
6 1/4" x 9 5/8"
Collection of Arthur Marx
Plate No. 5, p. 51

* 49. *Mitzvot (Commandments)*
Watercolor on paper, 1993
16 1/2" x 12 3/4"
Collection of Arthur Marx
Illus. on cover

* 50. *The Lulav*
Gouache on paper, 1994
19" x 15 1/4"
Collection of Siegmund Forst
Plate No. 6, p. 51

51. *Kiddush Levanah (Blessing the Moon)*
Oil on canvas, 1995
11 1/8" x 15 1/8"
Collection of Siegmund Forst

52. *Design for New Year's Card*
New York, 1995
Ink on paper
17" x 13"
Collection of Siegmund Forst

* 53. *Jonah*
Watercolor on paper, 1995
18 3/4" x 26"
Collection of Siegmund Forst
Plate No. 7, p. 52

* 54. *Messiah Coming (unfinished)*
Tempera on paper, 1997
25 1/4" x 19 1/4"
Collection of Siegmund Forst
Plate No. 8, p. 52

For his last painting, Forst has returned to a theme that has always intrigued him. In this unfinished work, the Messiah is depicted riding into Jerusalem on a donkey but the world is in flaming ruins. He is covering his face because he doesn't want to see what man has done to the world. Tradition teaches that the Messiah will reign in Jerusalem and rebuild the Temple. This enduring optimism, that things will improve for the Jewish people and the entire world, seems in contradiction to Forst's rather pessimistic view.

* 55. *Man with Chicken (Kaporos)*
Gouache on paper, n.d.
23" x 17"
Collection of Paul Gropman
Plate No. 9, p. 52

* 56. *At the Rebbe's Tisch*
Pastel and watercolor on board, n.d.
8 7/8" x 15"
Collection of William Loewy
Plate No. 10, p. 53

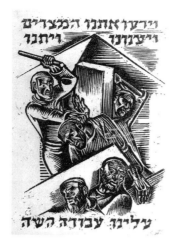

CAT. NO. 57

Graphics

* *57. Hagaddah Illustration*
"And the Egyptians did evil unto us and they tormented us and let upon us hard labor"

Woodcut on paper, 1937
6" x 4"

Collection of Siegmund Forst

Using blunt and bold lines and graphics, Forst portrays the Jews' toil and bondage against the backdrop of the powerful pyramids.

58. Forlorn Man

Woodcut on paper, circa 1950
8 3/8" x 4 3/4"

Collection of Siegmund Forst

59. The Jew and Peoples

Woodcut on paper, 1955
9 1/8" x 6"

Collection of Siegmund Forst

60. Mizrach

Linoleum cut on paper, circa 1960
13 1/4" x 11 1/8"

Collection of Siegmund Forst

* *61. Burning Man*

Woodcut on paper, circa 1960
10 3/4" x 8 3/8"

Collection of Siegmund Forst

Illus. on p. 37

62. Man with Chicken (Kaporos)

Woodcut on paper, circa 1970
8 7/8" x 5 7/8"

Collection of Siegmund Forst

63. Jonah and the Whale

Woodcut on paper, 1970
12 3/4" x 9 1/4"

Collection of Paul Gropman

64. Hanukkah

Woodcut on paper, 1975
13 1/4" x 10 1/8"

Collection of Siegmund Forst

* *65. Mizrach*

Wood engraving, 1976
14 3/8" x 11 3/4"

Collection of Siegmund Forst

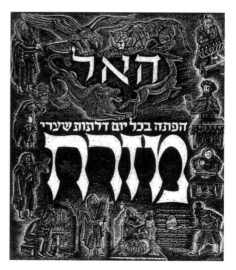

CAT. NO. 65

In countries west of Israel, a *mizrach* (literally "east") is used as a marker on the eastern wall of a home to indicate the direction of Jerusalem for prayer. There are no religious requirements dictated for its decoration and Forst has produced a number of varied examples.

66. Hassidim

Woodcut on paper, circa 1977
10 1/4" x 13 1/4"

Collection of Siegmund Forst

* 67. Martyrdom

Linoleum cut on paper, circa 1980
14 1/4" x 8 3/4"

Collection of Siegmund Forst

This intense black and white linoleum cut reveals Forst's deep personality. The angular faces of this family of four sum up their expression of deep sorrow. The mother shields the daughter's face with her protective hand, but the flames, rising from the four ovens of Auschwitz, consume them all. The ovens themselves are small in relation to the rest of the image. It is the family that is ennobled. What captures the eye are the flames as they take on the characteristics of angel's wings soaring to heaven, putting into perspective the idea that in Jewish tradition being sacrificed for our beliefs sends us closer to God. In the lower right hand corner of the work is a poem composed in Hebrew by Forst:

Flames go up
The heavens were illuminated
from furnaces of fire

Bodies burned,
cloaked in smoke,
consumed like burnt offerings

There remains the artist
without an image to envisage
Unless from that fireplace
a light for the Messiah
will be kindled

68. From the Chimneys

Linoleum cut on paper, 1980
23 1/8" x 11 1/4"

Collection of Siegmund Forst

69. Mizrach

Linoleum cut on paper, circa 1982
11 1/2" x 9"

Collection of Siegmund Forst

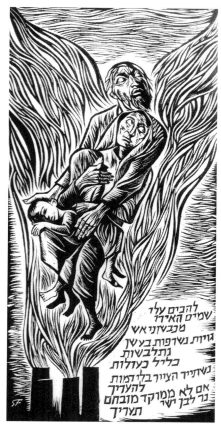

CAT. NO. 67

70. Purim

Linoleum cut on paper, circa 1987
14" x 9 1/2"

Collection of Siegmund Forst

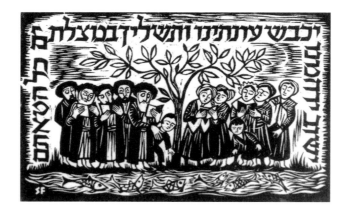

יכבש עונתינו ותשליך במצולת ים... ומשליך במצולת...

CAT. NO. 71

* *71. Tashlikh (Casting off Sins)*

Woodcut on paper, 1989
5" x 8 1/2"

Collection of Siegmund Forst

Forst always turned to his own sources of in-spiration, religious "slices of life" he knew well. This genre woodcut is comprised of an austere economy of line and simple, almost naive, images. On the first day of Rosh Hashanah, Jews proceed to a body of running water, preferably containing fish, and symbolically cast off their sins. In this image, a tree extends its branches like a protective umbrella, almost in balance, but not quite, thereby giving a slight tension to the entire design. The tension between the almost-mirror images of the right and left halves of the work is created by Forst's aware-ness and sensitivity to life's slightest, imper-ceptible moments and gives movement to the work. There is a didactic element to this work. Preferably, *tashlikh* is done at a body of water containing fish, since man cannot escape God's judgment just as fish cannot escape being caught in a net. Here the fish jump and swim in mindless pursuit liable to be ensnared and trapped at any time. This is the lesson that man must remember for, in this same way, man is identical to fish.

72. Messiah's Shofar

Linoleum cut on paper, 1989
13 3/4" x 14"

Collection of Siegmund Forst

73. Praying Man

Woodcut on paper, 1993
12" x 8"

Collection of Siegmund Forst

74. At the Rebbe's Tisch

Woodcut, n.d.
15 1/2" x 10 1/2"

Collection of Mr. and Mrs. Israel Friedman

Prints

* *75. Mizrach*

Reproduction of woodcut on paper
Vienna, Austria, circa 1928
12 1/4" x 11"

Collection of Lucy Lang

Illus. on p. 25

Dr. Leo Deutschlander, administrator for the Beth Jakob School for Girls based in Vienna, gave Forst the commission of this woodcut, his very first, which was then printed and used as a fundraising item. It depicts symbols of the twelve tribes of Israel, Jerusalem and the Messiah on a donkey blowing a shofar. Printed in the bottom right-hand corner is the follow-ing caption: Holzsnitt von Siegmund Forst; "Herausgegeben vom Beth Jakob" (Fond für Schule v. Erziehung Des Jüdischen Mädchens).

76. Alef-Bet Chart

New York, circa 1960

13" x 10"

Collection of Siegmund Forst

Plate No. 16, p. 55

Illustrating the letters and vowels of Hebrew, alphabet charts were probably first printed in the 16th century, and for many centuries most Jewish children were introduced to the Hebrew language by this simple medium.

77. Poster: Jewish Symbols

New York, circa 1960

13" x 10"

Collection of Siegmund Forst

78. Poster: A Jewish Library

New York, 1965

15 1/2" x 11"

Collection of Siegmund Forst

Books

Children's Books

79. Beit Yisrael—Ivrit Le-Mathilim

(House of Israel—Hebrew for Beginners)

New York, 1944

Text by Zevi Scharfstein

Shilo

The Moldovan Family Collection

The story line and illustrations in this primer clearly address the students' American experience. Forst's illustrations show happy, well-fed boys and girls, and there is no mention of the war, Europe, or the Holocaust.

* *80. The Jingle-Book for Jewish Children*

New York, 1947

Text by Ben-Ami

Shilo

The Moldovan Family Collection

Plate No. 13, p. 54, Illus. on p. 31

This collection of rhymes sought to educate American children about holidays and the Holy Land with joyful verses.

* *81. Noah and the Animal Boat*

New York, 1948

Text by Ben-Ami

Shilo

Collection of Siegmund Forst

Plate No. 14, p. 54

82. Let's Talk Hebrew

New York, 1951

Shilo Publishing House

Collection of Siegmund Forst

83. It's Time to Read

Text by Zevi Scharfstein

New York, 1951

Shilo Press

Collection of Siegmund Forst

Appearing to move from left to right through the book's title, the graphic device of a swinging pendulum suggests movement in an otherwise stable composition. The clock itself plays on the title and, incorporating the motif of the Star of David, is an artful image filled with the nuances of many interesting shapes intertwined with beautiful Hebrew calligraphy.

*84. Supplement for It's Time to Read

Text by Zevi Scharfstein
New York, 1951
Shilo Press

Collection of Siegmund Forst

Illus. on p. 34

The merging of calligraphy and image in the form of the tree makes this paperback a visual delight.

*85. The Book of Hanukkah

New York, 1958
Text by Saadyah Maximon
Press of Shulsinger Brothers

Collection of William Loewy

*86. Within Thy Hand: My Poem Book of Prayers

New York, 1961
Text by Ilo Orleans
Union of American Hebrew Congregations

Collection of Siegmund Forst

*87. Hofets Hayim: The Story of a Great Rabbi and Leader of the Jewish People

New York, 1962
Text by Moshe Prager
Jewish Education Press

Collection of Siegmund Forst

*88. The Book of Sabbath: Story and Traditions/ Songs and Music

New York, 1962
Press of Schulsinger Brothers

Collection of Rabbi Benjamin Forst

*89. Stories of Jewish Symbols

Text by Molly Cone
New York, 1963
Block Publishing Company, Inc.

Collection of Siegmund Forst

*90. Samson Benderly

New York, 1963
Text by Mamie G. Gamoran
Translated and adapted by Elhanan Indelman
Jewish Education Committee Press

Collection of Siegmund Forst

*91. Historia L'Yeladim: A Children's History

New York, 1965
Revised edition by Zevi Scharfstein
Shilo Publishing House

Collection of Siegmund Forst

*92. David, My Jewish Friend

Text by Alice L. Goddard
New York, 1967
Friendship Press

Collection of Siegmund Forst

*93. Shmuel Yosef: Agnon Stories

New York, 1973
Adapted by Elchanan Indelman
Jewish Education Press

Collection of Siegmund Forst

*94. The Story of the Unhappy King

New York, 1975
Text by Hannah Gruenebaum
Religious Art Production
"The Jewish Child Series" No. 4

Collection of Siegmund Forst

*95. The Mice, the Fox, and the Cheese

New York, 1975
Text by Hannah Gruenebaum
Religious Art Production

Collection of Rabbi Benjamin Forst

*96. The Magic Carpet

New York, 1975
Text by Hannah Gruenebaum
Religious Art Production

Collection of Rabbi Benjamin Forst

97. Lost in the Zoo on Erev Shabbos
New York, 1983
Text by Devora-Leah
The Judaica Press
Collection of Rabbi Benjamin Forst

98. The Little Midrash Says
New York, 1986
Bnay Yakov Publications
Slipcase: Collection of Siegmund Forst
Volumes: Collection of Lynn Broide

99. My First Siddur: a Selection of Prayers and Blessings for Boys and Girls
New York, 1989
National Committee for the Furtherance of Jewish Education
Collection of Rabbi Benjamin Forst

100. A Passover Story from the Prague Ghetto
Text by Gerson Kranzler
New York, n.d.
Produced by the Yeshiva Settlement, Mt. Kisco, New York
Saphrograph Company
Collection of Siegmund Forst

Haggadahs

* *101. The Haggada of Passover*
New York, 1941
Shilo Publishing House
Collection of Siegmund Forst
Illus. on p. 28
See also CAT. NO. 4

As a refugee who lived a year under Hitler in Vienna, Forst introduces the theme of the Holocaust into the contemporary Haggadah with his first work published in America. Even though he experienced slavery and oppression "in contemporary dress," he still emphasizes themes of hope and faith in God.

102. The Haggadah of Passover
New York, 1944
Text by A. Regelson
Produced for Barton's Bonbonnière by Shulsinger Bros.
Collection of Lili Wronker

103. The Haggadah of Passover
New York, 1944
Text by A. Regelson
Produced for Beth Jacob Schools (New York, NY) by Shulsinger Bros.
Collection of Lili Wronker

104. The Haggadah of Passover
New York, 1944
Text by A. Regelson
Produced for Beth Jacob Schools by Shulsinger Bros. Linotyping & Publishing Co.
Collection of Rabbi Benjamin Forst

* *105. The Children's Passover Haggadah*
New York, 1945
Translated by Ben-Ami Scharfstein
Music arranged by G. Ephros
Shilo Publishing House
The Moldovan Family Collection
Illus. on pp. 16, 31, 58

The illustration to accompany the text, "This Year Slaves" includes not only Egyptian taskmasters, but a history of anti-Semitic persecution, including Romans, Cossacks, and Nazi soldiers.

106. The Children's Passover Haggadah

New York, 1945
Translated by Ben-Ami Scharfstein
Shilo Publishing House

Collection of Rabbi Benjamin Forst

Illus. on p. 31

Based on a phrase from the Sabbath service, this light-hearted and uplifting two-page spread demonstrates Forst's ability to transmit a deep concept on a juvenile level. There is a narrative dimension to this work in which all disparate, visual elements are juxtaposed to tell the story. The curvilinear quality of images, such as the bending tree branch, the giraffe's neck nuzzling the puppy, and leaping monkeys, serve to enhance the quiet aspects of the overall image. The children, all with smiling faces, play and romp, and watch jovial fish bend with the waves while a frog and pelican look on. The normally ferocious lion allows children to sing and play the accordion on his back. A feeling of well-being and calm pervades the idealized landscape.

107. The Haggadah of Passover

New York, 1949
Shulsinger Brothers

Collection of Siegmund Forst

Plates 11, 12, 18, pp. 53, 56

108. The Haggadah of Passover

New York, 1951
Text by Abraham Regelson
Produced for General Israel Orphans' Home for Girls, Jerusalem by Shulsinger Brothers

Collection of Lili Wronker

109. The Haggadah of Passover

New York, 1951
Text by Abraham Regelson
Shulsinger Brothers

Collection of Yeshiva University Museum

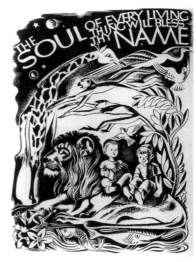

CAT. NO. 106

110. The Haggadah of Passover

New York, 1951
Text by Abraham Regelson
Produced for General Israel Orphans' Home for Girls by Shulsinger Brothers

Collection of Yeshiva University Museum

111. Passover Haggadah

New York, 1953
Text by Abraham Regelson
Produced for Home of the Sages of Israel by Shulsinger Brothers

Collection of Yeshiva University Museum

112. The Haggadah of Passover

New York, 1954
Produced for General Israel Orphans' Home for Girls by Shulsinger Bros.

Collection of Lili Wronker

113. The Haggadah of Passover

New York, 1955
Text by Abraham Regelson
Shulsinger Bros.

Collection of Lili Wronker

114. *Hagadah of Passover*

New York, 1956
Produced for United Charity Institutions by
Shulsinger Bros.

Collection of Lili Wronker

115. *The Haggadah of Passover*

New York, 1957
Produced for General Israel Orphans' Home
for Girls by Shulsinger Bros.

Collection of Lili Wronker

116. *The School Haggadah*

New York, 1958
Text by Saadyah Maximon
Shulsinger Brothers

Collection of Lili Wronker

117. *The Haggadah of Passover*

New York, 1958
Translated by Saadyah Maximon
Supplement by Rabbi Charles B. Chavel
Press of Shulsinger Brothers

Collection of Rabbi Benjamin Forst

118. *The Haggadah of Passover*

New York, 1962
Text by Saadyah Maximon
Shulsinger Brothers

Collection of Lili Wronker

119. *The Haggadah of Passover*

New York, 1962
Text by Saadyah Maximon
Produced for United Charity Institutions of
Jerusalem by Shulsinger Bros.

Collection of Lili Wronker

120. *Passover Haggadah*

New York, 1966
Text by A. Regelson
Produced for General Israel Orphans' Home
for Girls by Shulsinger Bros.

Collection of Lili Wronker

121. *The Passover Haggadah*

New York, n.d.
Produced for the General Israel Orphans'
Home for Girls, Jerusalem by Shulsinger
Brothers

Collection of Lili Wronker

122. *Passover Haggadah*

New York, n.d.
Text by Abraham Regelson
Shulsinger Brothers

Collection of Lili Wronker

123. *The Passover Haggadah*

New York, n.d.
Illustrated by Children of the Arts & Crafts
Class of the General Israel Orphans' Home
in Jerusalem [with additional illustrations by
Siegmund Forst]
Produced for General Israel Orphans' Home
for Girls in Jerusalem by Shulsinger Bros.

Collection of Yeshiva University Museum

Booklets

124. *Jewish Life Through the Year*

New York, 1954
Text by Rabbi Charles B. Chavel
Shulsinger Bros. Linotyping & Publishing Co.

Collection of Rabbi Benjamin Forst

125. *"Grace After a Wedding Meal"*

New York, 1968

Collection of Siegmund Forst

126. *Prayers and Blessings Illustrated*
New York, 1968
Religious Art Production
Collection of Siegmund Forst

127. *If I Forget Thee O Jerusalem…*
New York, 1978
Schulsinger Bros.
Collection of Rabbi Benjamin Forst

128. *Shabbat Shalom*
Prepared and designed by Siegmund Forst
New York, 1978
Produced for General Israel Orphan's Home
for Girls, Jerusalem by Shulsinger Bros.
Collection of Lili Wronker

Illustrated Books: Megillot

129. *The Five Megilloth*
New York, 1948
Ktav Publishing House
Collection of Siegmund Forst

130. *Megilloth Esther*
Edited by Rev. Dr. A. Cohen
Revised by Rabbi A.J. Rosenberg
London and New York, 1984
The Soncino Press
Collection of Siegmund Forst

131. *The Five Megilloth*
New York, 1984
Soncino Press
Collection of Siegmund Forst

132. *The Five Megilloth*
London and New York, 1984
Edited by Rev. Dr. A. Cohen
Revised and enlarged by Rabbi A.J. Rosenberg

The Soncino Press
Collection of Siegmund Forst

Ornamental Lettering on Book Covers

133. *Mikraot Gedolot*
New York, 1950
Shulsinger Brothers
Collection of Siegmund Forst

134. *Mishnah Torah*
Maimonides
New York, 1957
S. Goldman-Otzar Hasefarim, Inc.
Collection of Rabbi Benjamin Forst

135. *Sefer Kikayon D'Yonah*
Mt. Kisco, New York, 1958
Yeshiva Press
Collection of Siegmund Forst

136. *Mishnayot Yakhin and Boaz*
New York, 1974
M.P. Press
Collection of Siegmund Forst

137. *T'rumath Tzvi-The Pentateuch*
New York, 1987
The Judaica Press, Inc.
Samson Raphael Hirsch with excerpts from
The Hirsch Commentary
Collection of Siegmund Forst

138. *Pitchei Halakhah (Laws of Kashrus)*
New York, 1995
Text by Rabbi Benjamin Forst
Privately published
Collection of Rabbi Benjamin Forst

Miscellaneous

139. Book Jacket: *Das Volk des Hartenschlafs/Roman*
Vienna, circa 1930
Text by Oskar Baum
Collection of Rabbi Benjamin Forst

* *140.* Student Identification Card
Graphische Lehr-und Versuchsanstalt
(Vienna School of Graphic Arts)
Vienna, winter term, 1929-1930
Collection of Siegmund Forst
Illus. on p. 22

* *141.* Report Card
*Graphische Lehr-und Versuchsanstalt
(Vienna School of Graphic Arts)*
July 5, 1930
Collection of Siegmund Forst
Illus. on p. 21
Note: The grade of "sehr gut"

142. Periodical: Menorah:
*Jüdisches Familienblat für Wissenschaft/
Kunst und Literatur*
November/Dezember, Nr. 11/12, 1932
Collection of Siegmund Forst

143. Pamphlet
*"Our Brothers in Europe Call to You in the Last
Hour! Save Them Now! Before It Is Too Late"*
New York, circa 1942
Emergency Rescue Committee of Adas
Yereim, Inc.
Collection of Rabbi Benjamin Forst

144. Magazine Title
"Doar"
New York, 1950
Gouache on bristol board
Collection of Rabbi Benjamin Forst

* *145.* *A Treasury of Tales of the Jewish People*
Unpublished manuscript
New York, 1950
Text by Siegmund Forst
Collection of Siegmund Forst
Plate No. 4, p. 50

In this incomplete compilation of unpublished
Jewish traditional stories, the changes and cor-
rections permit a charming insight into Forst's
creative spirit.

146. *Design for Projected Memorial for the
Martyred Jews*
Newburgh, New York, circa 1955
Collection of Rabbi Benjamin Forst

* *147.* *Kiddush Cup*
Designed by Siegmund Forst
Silver
Manufacturer: Unknown
circa 1960
approx. 5 1/2" high
Collection of Siegmund Forst
Plate No. 17, p. 55

148. *Megillah Case*
Sterling Silver
Middle section designed by Siegmund Forst
Silversmith unknown
Israel, 1960
12 1/4" high
Collection of Rena Kronenthal

149. *Ketubbah Cover*
Commercially printed
New York, circa 1960
Collection of Siegmund Forst

150. *Stamps*
New York, circa 1960
Published by the Yeshiva Derech Ayson
Collection of Siegmund Forst

151. *Ketubbah*

Commercially printed, circa 1960
14" x 9"

Collection of Siegmund Forst

152. *Advertisement reprint from* The New York Times *for Barton's Bonbonnière*

circa 1960

Collection of Yeshiva University Museum

This advertisment describes the traditional way to make a Seder and includes all the necessary elements of the Passover table. The Haggadah at each place setting, containing the complete Seder ceremonies in their prescribed order, was illustrated by Forst and published in paperback in 1951 and in cardboard covers in 1955.

* 153. *Sukkah (Detail)*

Spero Foundation, New York
Plastic, circa 1965
34 1/2" x 60"

Collection of Lynn Broide

Plate No. 15, p. 55

Forst is responsible for many items of material culture that have appeared throughout the years in the Jewish household. This Sukkah is a noteworthy example. In the 1960s, the Spero Foundation asked Forst to decorate a pre-fabricated sukkah, which he did with fruits, birds, and representations of the seven species of the land of Israel. This Sukkah was produced first in heavy canvas and then in plastic, a detail of which is on exhibition.

* 154. *Passover Plate*

Designed by Siegmund Forst
Art Decal Company
Transfer print on ceramic
circa 1967
11" diameter

Collection of Siegmund Forst

Plate No. 17, p. 55

155. *Commemorative Medal*

U.S.–Vietnam Peace Agreement
January 27, 1973
Designed by Siegmund Forst
2" diameter

Collection of Siegmund Forst

156. *Commemorative Medal*

Israel's 25th Anniversary 1948–1973
Designed by Siegmund Forst
2" diameter

Collection of Siegmund Forst

157. *Book Jacket: Selichot*

New York, 1988
The Judaica Press

Collection of Siegmund Forst

158. *Wedding Invitation*

Bride: Naomi Gruenebaum;
Groom: Nusson Cohen
New York, 10th day of Sivan 5749 (1989)

Collection of Siegmund Forst

159. *Woodblocks and Woodblock Tools*

Collection of Siegmund Forst

160. *"Shalom" Plaque*

Produced for General Israel Orphans' Home for Girls, Jerusalem by Shulsinger Bros.
Plastic, n.d.
4" x 6 3/4"

Collection of Lili Wronker

161. *Design for Torah Shield*

New York, n.d.
Ink on paper

Collection of Rabbi Benjamin Forst

162. *Selection of Various Book Jackets*

Collection of Siegmund Forst